black & white **digital** photography

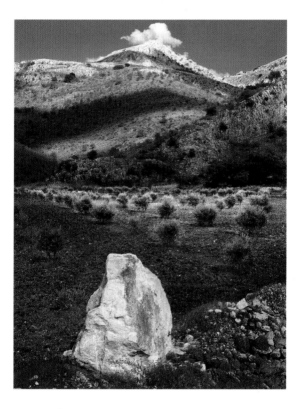

black & white **digital** photography
creating & manipulating great monochrome images

LES MEEHAN

COLLINS & BROWN

First published in Great Britain in 2005 by
Collins & Brown
The Chrysalis Building
Bramley Road
London W10 6SP

An imprint of **Chrysalis** Books Group plc

Distributed in the United States and Canada by Sterling Publishing Co.
387 Park Avenue South, New York, NY 10016, USA

1 3 5 7 9 8 6 4 2

British Library Cataloguing-in-Publication Data:
A catalogue record for this book is available from the British Library.

ISBN 1 84340 190 8

Designer: Rod Teasdale
Project editor: Miranda Sessions
Commissioning editor: Chris Stone

Reproduction by Classicscan Pte Ltd, Singapore
Printed and bound by Kyodo Printing Co Pte Ltd, Singapore

Contents

Introduction

Digital photography has become part of many people's lives as more and more families have replaced their older film-based cameras with newer digital models. These mass market digital cameras offer features that film cameras could not, such as recording movies, because of the electronic recording medium used to replace traditional film. Although the 'happy snapper' market has been quick to adopt the low- to medium-quality digital camera, more serious photography enthusiasts and working professionals have needed to wait until digital cameras arrived at the point where they could reasonably be said to produce image quality similar to that of a traditional film camera. In the 35 mm format this was been a frustrating wait.

Digital capture backs have been available for large-format and medium-format cameras for several years, though with a hefty price tag (although the prices are now coming within the professionals' range). It is only fairly recently that 35 mm format digital cameras have been able to rival high-quality 35 mm film cameras with regard to image quality. With professional digital 35 mm cameras now capable of recording 12 megapixels and more, serious photography practitioners can at last confidently exchange their 35 mm film cameras for digital models.

Of course, serious monochrome photographers have been following the advance of digital technology with close interest. Since many monochrome specialists use medium or large format, the relatively slow development of 35 mm digital cameras has not been a great burden.

Of greater interest has been the development of reasonably priced high-quality film scanners and photo-quality inkjet printers to allow in-house digitizing of monochrome negatives and the production of fine-quality prints. At last, these items produce sufficient quality at an acceptable price, so that serious users can confidently convert completely to digital. Many, like me, have been slaving away in a darkroom for decades honing their skills with the aim of producing fine monochrome prints. Frankly, after many years, darkroom work can be plain tedious and it is refreshing to be able to choose whether to use traditional darkroom printing or the more flexible (and user-friendly) digital methods.

This book has been written both for the experienced monochrome photographer, who is looking to change from the traditional darkroom to the digital lightroom, and for the newcomer to black and white digital photography. Although I have tried to make the book camera-format independent (i.e. not just for 35 mm users), there are some camera techniques that are possible only on digital cameras and these must be covered. Since many serious monochrome photographers prefer to record the image on film and then scan the resulting negatives – still the only economic option for medium- and large-format users – there is a large section dealing with the technique of film scanning. The book then looks at ways of recreating various traditional darkroom techniques using digital methods and finishes with a section on the making of high-quality digital prints.

Olive trees (opposite)
Black and white photography has finally diverged into a new and exciting creative arena. Digital tools and techniques now provide photographers with the artistic freedom they have always desired. Can you guess where the telephone poles and wires were in this shot?

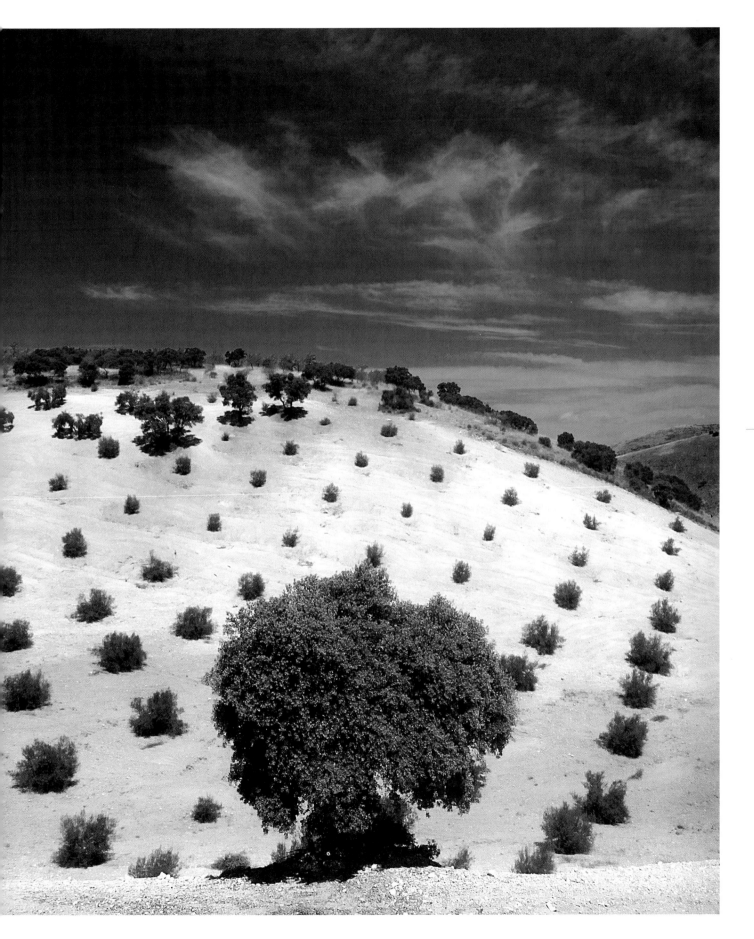

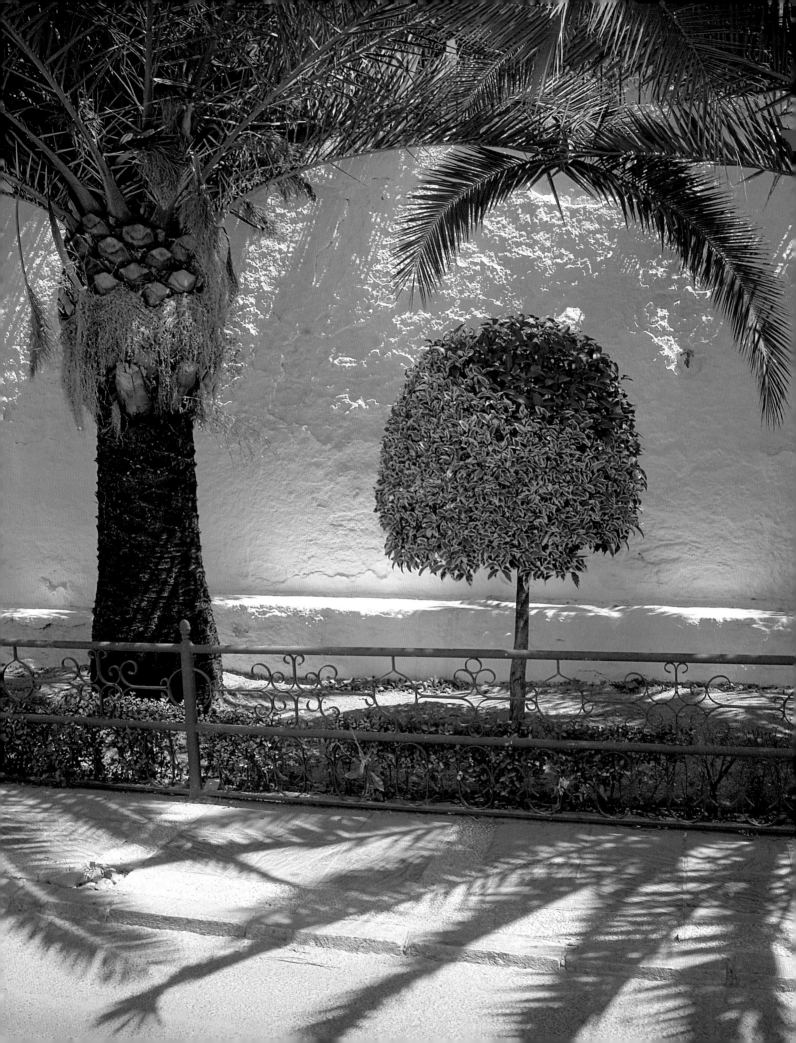

Chapter 1
Tools and concepts

This chapter starts with a general overview of the hardware and software required for digital photography. Since the camera hardware and image software are designed primarily for colour imaging, there are relatively few monochrome-specific features. However, these will be emphasized where appropriate.

Following hardware and software, the basics of image formation and file formats are discussed, together with a look at some of the factors that influence image quality. Some of this information is essential to gain a thorough understanding of digital imaging and some is provided as practical advice and food for thought.

Finally, although this is a book on black and white photography, colour has always been a strong part of monochrome printing in the form of toning, handcolouring and other methods of applying colour to a black and white image. Therefore the chapter ends with a brief look at basic colour theory since this will be essential to understanding many of the techniques demonstrated later in the book.

Palm shadows (opposite)
Understanding the digital tools allows you to emerge from the gloom of the darkroom and step into the light of the digital world. However, don't lose sight of the fact that black and white pictures still rely on light and shade for their impact.

Digital cameras and scanners

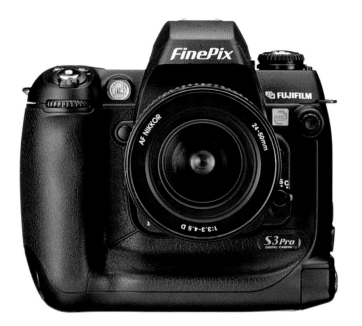

Fuji S3 Pro (above)
The Fuji professional digital SLR cameras use a uniquely designed CCD capture method that increases the range of subject contrast the camera can handle. The patented pattern of the CCD also helps to capture fine detail. As with all pro cameras, the Fuji model shown here has a range of system accessories available.

Canon EOS 1 Mark II (below)
Canon have quickly gained a reputation for producing fine digital cameras that are very competitively priced. Their flagship model, shown here, offers even the most demanding photographers all they could wish for in a digital SLR and also has a wide range of system accessories.

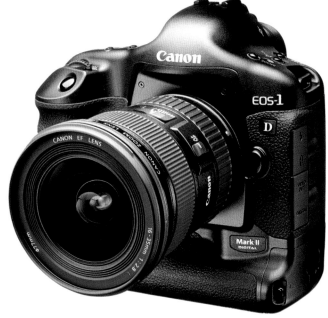

Digital cameras
For digital-only photographers the main method of obtaining digital picture files is to use a digital camera. Although any digital camera can be used for black and white photography, serious users really need the flexibility and image quality offered by a digital SLR (single lens reflex) camera. Since the number of effective pixels recorded by the camera directly influences the maximum print size attainable without interpolation (a process of artificially increasing pixels by averaging the values of surrounding pixels to obtain new ones) of the image data it makes sense to buy a camera with as high an effective pixel count as possible. For the serious user a camera with an effective pixel count of at least six megapixels should be considered the minimum where prints over 10 x 8 in will be required.

Pixel count is only one factor to consider; it should also be regarded as essential that the camera images can be saved in the RAW file format. This format is the 'purest' since the camera does not perform any corrections to the captured data. The files can then be opened using a specialist RAW converter (Photoshop CS now has RAW conversion built in for most makes of camera) which usually provides advanced features to control and refine the native image data.

Other factors to consider are the traditional camera features such as shutter speed range, ISO range, lens range (not usually a problem!), exposure meter system (in my opinion full manual operation and spot metering should be considered essential), auto and manual focus, speed of operation (when saving files), battery life and basic handling.

All of these things can be researched via the manufacturers' product brochures plus reviews in magazines and on the internet (a wonderful resource for digital equipment reviews is www.dpreview.com).

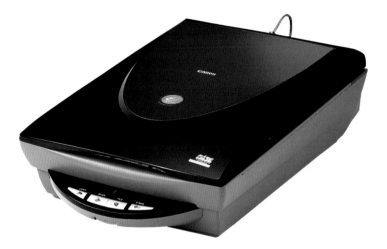

Canon 9950F scanner
Most major equipment makers now offer flatbed
scanners with advanced film scanning capabilities.
The example shown here is from the Canon range and
can scan different film formats with exceptional quality.
One of the advantages of a flatbed is that it can also
scan prints and other objects.

Scanners

The alternative method of obtaining a digital image file is to scan either an existing piece of processed photographic film or a finished print. Scanners are essential to the photographer who prefers to continue to make negatives or who may have existing ones, especially in medium to large formats, and wants to utilize digital techniques with the images. Film scanners have improved dramatically and it is now normal for a photographer to scan film in-house rather than paying for expensive high-quality drum scans (although these still produce the best results).

Film scanners are either dedicated units that can be used only for film scanning or the flatbed type that, when equipped with a film adaptor, can be used to scan film and prints (as well as anything else). The main things to consider when choosing a scanner are the true optical sample rate (usually expressed as dpi, or dots per inch), the density range and the bit depth. Scanner quality is usually specified using two numbers for the dpi, e.g. 4800 x 9600. The first figure is usually the true number of samples per inch taken across the width of the scanner while the second figure specifies the number of discrete steps the scanning head takes during a scan. Density range indicates the actual range of film densities (or print tones) that can be detected by the scanner. In theory, the higher the density range the more unique film densities the scanner can record. In reality the figures quoted for

density range are often rather optimistic. However, most recent scanners can cope with even the most extreme slide or negative. The bit depth (a 'bit', or binary digit, is the smallest unit of computer storage) indicates the number of unique colours that the scanner can record for each sample/pixel of data. The normal bit depth is now 48 bits (16 bits per RGB colour channel) which allows millions of different colours. High bit depths result in smoother and more accurate colour and permit greater image manipulation with less tonal degradation.

Using scanner resolutions above the true optical resolution requires the use of a method known as interpolation, which produces new pixels to insert between the true pixels. The colour and tonal values of adjacent pixels are compared and averaged to produce a new interpolated pixel which is then inserted among the original pixels. Using interpolation to achieve bigger image sizes always results in a lower quality image and should be avoided if possible. Conversely, when a resolution lower than the optical maximum is used the image is down-sized by discarding pixels that are not necessary to the image. Again, this is an averaging method and results in a less than optimum result, although the quality loss is not as apparent as when increasing image size with interpolation. These methods are also used by digital cameras when different image sizes are chosen.

The Computer

Computers

Even the entry-level computers purchased for the home are now so powerful that they can all be used successfully for digital photography. With fast processors (CPUs), large amounts of fast internal RAM (random access memory), powerful graphics cards, large hard discs for storage and DVD recorders for archive storage, deciding which computer to buy is much less of a problem than in the past. A computer with a 3 GB processor, 1024 MB of RAM and 120 MB of hard disc storage will handle almost any digital image you care to throw at it. The basic rules are to have as much RAM as possible, which speeds up image processing by avoiding the system using the hard disc as virtual RAM, and to have a large hard disc to store all those big image files.

Monitors

For serious digital imaging, an essential item to consider is the monitor. Although many computers are sold with TFT (thin-film transistor) monitors, these are less than ideal for digital imaging, due to the problem of the display changing as you move your head relative to the screen. The best option is a large CRT (cathode-ray tube) monitor with a viewing area of at least 48 cm (19 in) but preferably 53 cm (21 in). With imaging software taking up screen space with palettes and tool bars, it is good to have plenty of room left to see as much of the image as possible at once. This avoids the rather annoying habitual scrolling of the image window that is necessary with smaller screens. Monitors from leading makers are also more stable and easier to calibrate, due to the range of controls provided. Monitors are usually specified in terms of resolution settings, dot pitch (the size of the screen pixels) and refresh rate (how fast the display is renewed). Larger screens allow higher resolutions, resulting in more desktop area and a sharper-looking display. Be careful never to exceed the recommended settings for the monitor, which may result in permanent damage to the monitor and possibly the graphics card.

It is a good idea to have some form of hood (easily made from black card) around the monitor screen to prevent extraneous light hitting the screen from the environment. When light from the room is reflected from the monitor it causes a reduction in the visual contrast and colour saturation of the display. This makes it more difficult to assess the displayed image accurately. As well as a fitting monitor hood, it also helps to work in subdued room light.

Memory card reader

With high-spec imaging computers a memory card may be built-in but there are separate units, such as the model shown here, that can be added to any computer. It makes it much easier to transfer your images.

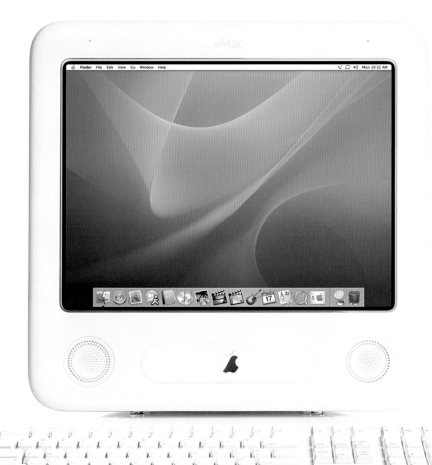

Computer and monitor

Modern computers, apart from having great specifications, are also being designed to look good on your desk. For digital imaging, almost any modern entry-level computer has more than enough power for most users.

Graphics tablet

Digital imaging with only a mouse for drawing selections is not a pleasant experience. Therefore, an essential item for your desk is a graphics tablet with a pen stylus. These can be obtained at reasonable prices and make a world of difference to your work flow.

External storage

In traditional film-based photography the issue of negative storage was never too complicated. As long as the negatives were kept in suitable archive quality sleeves, in a relatively dry and dark place, you could expect them to stay in pristine condition for generations. Unfortunately, with digital imaging the situation is not so simple.

Since image files produced with digital cameras and film scanners are in digital form only they must be stored on the available physical media. It quickly becomes apparent that the hard drive built into a computer fills up very rapidly when you start saving digital image files (which can become very large) and it is necessary to consider external storage. At the time of writing the current external medium of choice is the DVD disc format (prior to DVD it was the CD disc format), but storage technology never stands still and every couple of years (or so it seems) new methods of digital storage surface to replace what already exists. This presents a problem to the digital photographer, who may

Portable hard drive

The memory card in a digital camera is quickly filled with images, so a useful addition is a portable hard drive similar to the one shown here. The images on the memory card can be transferred to the hard drive whilst on location to allow you to continue shooting.

have many thousands of digital images stored on discs. You either have to maintain the ability to read the older discs or to copy all the files on the old discs onto the new format discs – which is time-consuming and expensive. The difficulty is compounded by the fact that, more often than is necessary, different manufacturers may create proprietary formats, based on the agreed standard, to suit their own equipment. An example of this is the current DVD system, which includes the formats DVD+ and DVD-.

There is no really good solution to this problem. All you can do is use the current external storage available, such as DVD, and update as and when it becomes essential to do so. The main thing is to be logical and methodical in the way you catalogue your digital files on the physical media. Use suitable storage cabinets for the discs that can be expanded as the number increases, and introduce a filing system right from the first disc so that it will be easy to locate individual images both now and in the future.

Portable DVD/CD writer

If you want to transfer images directly to disc then there are portable CD or DVD writers available. Like portable hard drives, these can be very useful on location.

External hard drive

For people with an over-full hard drive in their computer, an easy solution is an external hard drive. These can often be linked together (known as a RAID system) for those that require large amounts of hard disc space.

Photo Printers

Dedicated photo printers
Dedicated printers, such as those shown here, produce high-quality prints using either inkjet or dye-sublimation printing. Models are available for making prints up to A4 in size (although many produce only postcard-size prints).

The most common and cost-effective printer for good-quality digital photographic printing for the home user is based on inkjet technology. 'Photo-printers' offer the user the freedom and versatility to produce both colour and monochrome exhibition-quality prints. The printing quality of inkjet printers has improved rapidly in the past few years to the point where many leading figures in the traditional world of fine-art monochrome printing have abandoned their darkroom printing in favour of inkjet printing.

The print quality that a particular printer is capable of producing is a combination of various parameters. These are: the size of the individual ink droplets used, how the ink is applied, the printer driver (software), the type of ink and paper used in the printer, and whether the printer has been correctly calibrated by the user for optimum results.

Printer quality is often quoted in terms of dpi. For example, the latest Epson professional A3 printers produce output at a maximum of 2880 dpi. However, when actually printing, the printer uses far fewer dots of ink per inch than the maximum dpi would suggest, since it must mix the different ink colours together to produce the various colours in a full colour or toned mono

image. As a general rule, the actual dpi used is that chosen in the printer driver software (e.g. 2880 dpi, 1440 dpi.) divided by the number of inks the printer uses. So, when using a setting of 2880 dpi in the printer driver with a printer that has six inks, the maximum dpi the printer can achieve is 480 dpi. However, the dpi setting is only one determinant of print quality. The visual appearance of the print owes much to the other factors mentioned above.

Other options are available for producing prints from digital image files. Dedicated printers are available from various manufacturers as part of their photographic systems. Alternatively, larger, high-quality professional prints can be produced by your local photo lab.

Ink-based photo printers

The most popular photo printers use inks or pigments and can produce large prints. The models shown here produce prints up to A3+ in size. The Epson printer uses inkjet technology while the Canon model uses the manufacturer's proprietary bubble jet system. Both systems are capable of fine-quality printing.

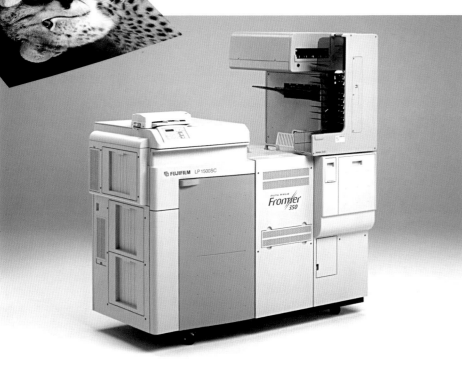

Commercial photo systems

For printing digital images on traditional photographic media, professional photo-finishing labs use advanced digital minilab machines such as this Fuji Frontier system. These machines are capable of producing exceptionally high-quality results on traditional photographic paper and are normally used by commercial photographers.

Scanning software

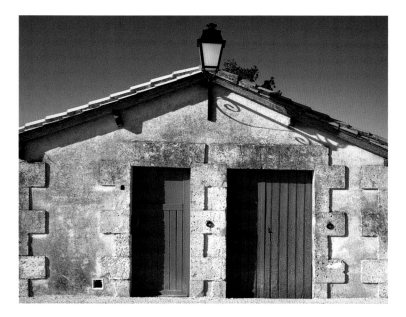

Scanners (and other types of external equipment) require dedicated UI (user interface) and driver software. The driver software allows the operating system to communicate with the scanner and the UI gives you access to the features and controls available on the scanner.

TWAIN

To allow graphics software access to different external equipment via a common system, a standard known as TWAIN has been established. All scanners (and printers) are supplied with a TWAIN-compliant interface that seamlessly integrates with any TWAIN-aware editing software. This means the same scanner can be used with the same UI directly from within programs such as Photoshop, Painter or Paint Shop Pro.

Although TWAIN is the usual method of interfacing scanners with editing programs, the scanner software can also often be used independently as a stand-alone application.

Doors and lamp – Epson software

This image was scanned with the TWAIN software provided by the scanner manufacturer. The screen grabs show the various control dialog boxes. I later toned this version using the Hue/Saturation method.

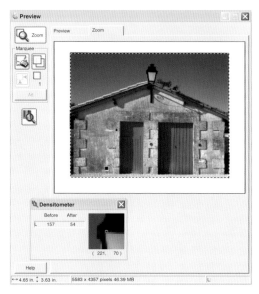

Main control centre

The Epson software has all the main parameters contained in this dialog.

Epson preview window

The preview window shows the result of any changes to the scanning parameters. Usually a digital densitometer is also provided for precise tone value assessment. Unfortunately, the preview window is rarely 100 per cent accurate and the final scan may well look different.

Curves adjustment

The best and most flexible method of adjusting the tonal values of the scan is to use the Curves adjustment dialog shown here.

This version was scanned using the SilverFast software. Each scanning program produces unique results and will require different adjustments to achieve similar results even from the same original negative.

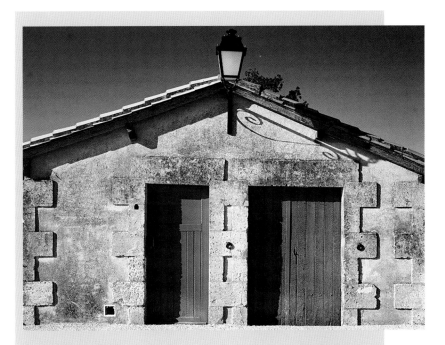

Independent scanning programs

Although all scanners are provided with a TWAIN interface, independent specialist scanning software is also available. Two of the best known independent applications are SilverFast from LaserSoft Imaging (www.SilverFast.com) and Vuescan from Hamrick Software (www.hamrick. com). Since these are specialist applications they can often produce superior scans than the equipment manufacturer's TWAIN interface. However, before buying any independent software you should make certain that it supports your particular scanner and can produce at least 48-bit colour.

SilverFast

SilverFast is a full-featured scanning application that can be run as either a stand-alone or a TWAIN application. It has all the usual image controls for pre-scan tone and colour adjustment, as well as more specialized controls for colour- to mono-conversion, grain reduction, dust and scratch removal and calibrated colour management.

Vuescan

Vuescan is also a highly respected piece of scanning software written by Ed Hamrick. Although the UI is not as graphically oriented as other programs, once mastered the software is capable of scans of the highest quality. It is especially well known for its ability to scan colour and monochrome negatives and is supplied with a large number of film type presets. One of the nice features of Vuescan is the ability to save the raw scan to disc, allowing you to go back and change any setting without having to rescan the original.

SilverFast control centre and preview window

These screen grabs show the main dialog and preview of the SilverFast software.

Film dialog and curves dialog

The SilverFast program has built-in refinements for different film types, which can be selected in this dialog. The Curves adjustment dialog shows how different settings were needed to achieve a scan similar to the Epson version.

Editing software

To get the most out of your digital imaging work you need a good image editing application. Your choice of application will depend on the features that are important to you and on your budget. Professional users will normally adopt the industry leader, Adobe Photoshop, as their choice of editing program since it is capable of doing almost everything the professional user may require. However, high-end professional software is still very expensive and often not necessary for many users. Lower cost programs whose feature list has been steadily added to over a period of time, such as Paint Shop Pro, will more than suffice for the majority of non-professional users. Alternatively, some people may prefer the cut-down version of Photoshop, called Photoshop Elements, which has a similar but more user-friendly interface with many semi-automatic features to help the novice user.

It is not uncommon for serious users to install more than one editing program. The following are the main applications of interest to the serious image maker.

Adobe Photoshop
The leading professional application has all the features and tools you will ever need, together with extended 48-bit colour image support. Adobe Photoshop (www.adobe.com) is also supported by many independent software creators, allowing the applications feature list to be extended using 'plug-in' software.

Adobe Photoshop Elements
The budget version of the professional Photoshop, Elements offers many useful features and helpful guidance for the hobbyist user. Although it is a useful entry-level application, more serious users may quickly become frustrated with the reduced features.

JASC Paint Shop Pro
Paint Shop Pro from JASC Software (www.jasc.com) is one of those applications that has grown in stature and features over several years. A reasonably priced application, it none the less offers many advanced features, rivalling more expensive software. This application also

Adobe Photoshop CS

This screen shot shows a typical layout of the main window of Photoshop CS. A useful feature is that the various palettes can be grouped together, as shown here on the right, to allow you to personalize the window layout.

JASC Paint Shop Pro

PSP is a very useful and versatile piece of software: as this screen shot shows, there are numerous tool bars and palettes available. I guarantee you will find this software useful.

Picture Window Pro

This is a powerful piece of image editing software that should be in every serious photographer's arsenal. Unlike Photoshop, which is designed for different users from photographers to web designers, Picture Window Pro is specifically geared to the needs of photographers.

has unique features not found on other programs, such as the very versatile screen capture command (which I used for all the screen grabs shown in this book). Even professional users usually have a copy of PSP available for access to these unique features.

Picture Window Pro

This is another powerful but affordable application, with many advanced features, produced by Digital Light and Colour (www.dl-c.com). It has strong support for 16-bit mono and 48-bit colour images, excellent colour management, good colour-to-monochrome conversion, a great image browser and much more. This program specializes in transformations, which are controlled via a preview window: when applied the new modified image is opened in a new window (a method unique to this program). This retains the original image window intact for comparison. This program is an excellent alternative to Photoshop for the serious user.

Cataloguing software

It doesn't take long, especially when using a digital camera, for your hard drive to become crammed full of digital image files, or to accumulate large numbers of image files saved on to DVDs. From the start, then, it is important to adopt a stringent housekeeping and archiving system so that you can organize your image files. To achieve this you really need to invest in some form of image cataloguing software.

Using cataloguing software will enable you to give meaningful names to your files and add additional information about each image, such as a caption, location and camera details. Once your images are catalogued and archived on to DVD discs (with low-resolution previews stored on the hard drive), you can use the software's advanced search facilities to locate individual images rapidly without constantly having to load and search every DVD disc.

Portfolio

One of the best and most powerful cataloguing applications is Portfolio from Extensis (www.extensis.com). This program has advanced viewing and search facilities for cataloguing digital image files. Portfolio has EXIF (exchangeable image file) support allowing it to retrieve the metadata stored by digital cameras in image files. This allows all the camera settings for an image to be stored as fields in the catalogue database. These fields can then be used as search criteria if desired.

Extensis Portfolio 6 (above)
Designed to look similar to the normal Windows file browser, Portfolio 6 is shown in thumbnail view in this screen shot. The folder tree is displayed in the folders panel on the left.

Portfolio 6 - Options (right)
This view shows some of the options available in Portfolio 6. In the background the images are shown in list view. The Item Properties dialog on top is where information for each image is entered and displayed. Although time-consuming, it is important to add information to each image in order to take advantage of the various search and sorting options provided by cataloguing programs.

FotoStation Pro

Another excellent image cataloguing application is FotoStation Pro from Fotoware (www.fotoware.com). Like Portfolio, it allows the user to store text fields and information with each image. Its advanced search facilities can then be used, based on the stored text fields, for the rapid retrieval of image files from either the internal hard disc or external archived discs. Fotostation also has a useful, built-in image editor where you can perform basic image editing tasks.

Fotostation

This screen grab shows the main window of the Fotostation cataloguing program in thumbnail view. The tabbed dialog allows you to change the way you preview the selected image instantly. As usual, access to other folders is provided in the folders panel on the left side of the window.

Fotostation – image details

The Text dialog allows you to add a mass of different information to each image in the catalogue.

Bits and Bytes

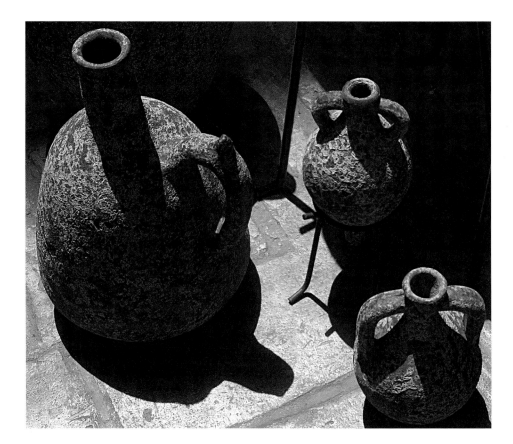

To make the most of your digital image explorations it is useful to understand how a digital file is constructed. This will allow you to understand better how image editing programs perform their tasks, such as when blending layers together, and thus increase your ability to select the best technique for a particular image.

· A digital file is composed of millions of individual bytes of information. A byte is a measure of computer storage that contains 8 bits (binary digits) of information. Using binary maths (i.e. 2^8), we see that one byte can store the range of whole numbers (integers) from 0 to 255.

8-bit greyscale

Since the human eye can normally detect a maximum of around 200 different grey values, it is possible to simulate digitally the continuous grey values of a complete grey scale using the numbers between 0 (black) and 255 (white), producing a range of 256 unique steps. Hence, for a monochrome image, one byte of storage

Water jugs – 8-bit greyscale (above)
Black and white pictures are usually 8-bit images based on a range of 256 different grey values.

holds the numeric equivalent of one grey value. Black and white images that use one byte to store each grey value are referred to as 8-bit greyscale images.

24-bit colour

Taking this a step further for RGB colour images or toned monochrome RGB images, any colour can be reproduced using a combination of the three primary colours – red, green, and blue (RGB). Therefore, to produce a full colour or toned mono image digitally it is necessary to use one byte of storage for each primary colour value. Thus, it takes three bytes of storage for each separate colour in the image. RGB images

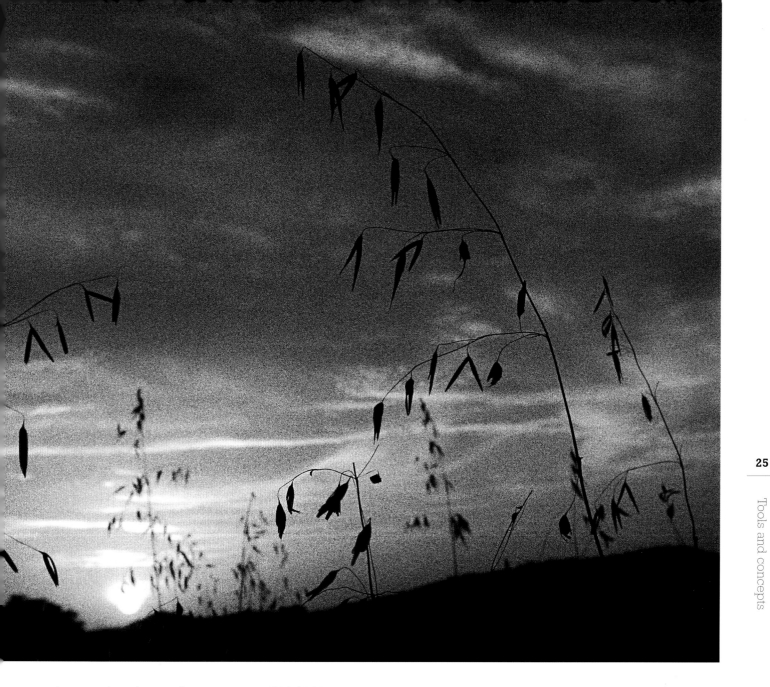

that use three bytes of storage are called 24-bit colour images and can contain 16.8 million different colours. This explains why an RGB colour image file of the same pixel dimensions as a greyscale image file requires three times the storage capacity.

16-bit and 48-bit files

Modern scanners can capture more essential image data by storing each unique tone or primary colour in two bytes of storage instead of only one. Thus, a 16-bit (one byte contains 8 bits) monochrome image can contain up to 65,536 (i.e. 2^{16}) different grey values. A 48-bit RGB image can contain 2^{48} different colours (you do

Grass sunset – 24-bit RGB (above)

Full colour and toned black and white pictures are usually 24-bit images with a possible range of 16.8 million colours. This is more than enough to simulate almost any natural colour.

the maths – it's a BIG number). The human eye cannot possibly distinguish the minute levels of change that these large numbers represent, so why bother? Simply, the more basic image data produced by the scanner, the more you can manipulate it without creating tonal/colour distortions. The larger file allows for more extreme tonal enhancements without ruining the smoothness of the printed tones and colours.

Pixels and file formats

Pixels/resolution

Now we know that each grey value in an 8-bit mono image takes one byte of storage we can relate this to image pixels and resolution. It has become common practice to refer to the smallest unit of image data as a pixel (picture element): each pixel represents one piece of the digital image. So, a greyscale image requires one byte of storage per pixel and an RGB image requires three bytes per pixel. Pixels are used to specify the dimensions of a digital image; for example, a digital camera may produce an image of 4256 x 2848 pixels.

Resolution usually acts as a measure of output and, together with pixel dimensions, is used to determine final output size and quality. Resolution is generally specified in dots per inch (dpi). Think of this as the number of image pixels that will be crammed into one inch of printed output. Higher-output resolutions usually produce higher-quality results (within the limits of the output device) because more image pixels are used in each inch of output.

Image file and print sizes

Pixel dimensions can be used to determine the storage required for an image. To calculate how many megabytes (MB) of storage an image will require, simply multiply the height by the width in pixels and divide by 1024 twice (W x H/1204^2). For example, an image of 1200 x 900 pixels requires 1.03 MB of storage. This calculation is useful when determining the image capacity of memory cards and other storage media.

As previously stated, pixels are commonly used to specify the dimensions of a digital image and resolution to specify print output. Using these together you can determine the printed size of a digital file. For example, if the pixel dimensions are 1200 x 900 and you specify an output resolution of 300 dpi, then the final print size will be 4 x 3 in (1200/300 dpi = 4 in). However, changing the output resolution of the same image to 240 dpi will produce an increase in print size to 5 x 3.75 in. There is a standard relationship between

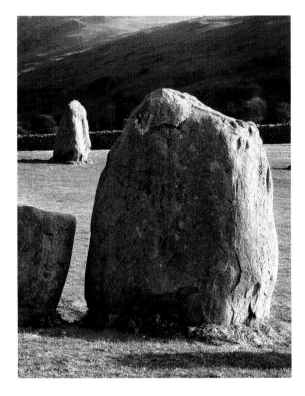

Castlerigg – image composition
All digital images are composed of picture elements, or pixels. As in this toned black and white image, the image pixels are usually so small that they cannot be seen with the naked eye.

Section of image pixels
This close-up section of the top of the main rock from the Castlerigg picture shows the image pixels enlarged so that they can be seen. Note that the pixels are square: this leads to an effect called 'jaggies' in low-resolution or over-enlarged images, in which diagonal and circular lines take on a stepped appearance.

Image file compression

These two images illustrate the use of compression when saving a picture. The first (above) was saved using TIFF compression with the LZW option (see upper-screen shot dialog). This is a loss-less method that retains full image quality. It reduced the stored file size from 11 MB to 4.6 MB. The second image (below), was saved in the JPEG format using a quality setting of 8 (see lower screen shot dialog). This lossy method considerably reduces stored file sizes, here from 11 MB to 382 KB, but does reduce image quality. However, the JPEG compression is so efficient that you probably won't be able to notice much difference between the two versions shown here.

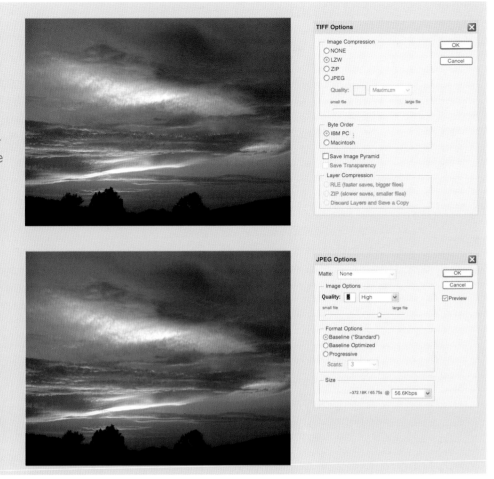

pixel dimensions and output resolution. For the same image pixel size, increasing output resolution reduces print size, while reducing output resolution increases print size. (It is important to remember that this has nothing to do with the resolution settings of your printer.)

Formats and compression

Numerous methods have been devised for the efficient storage of different media files and these are known as file formats. For digital photographs, the main independent file formats in common use are TIFF (Tagged Image File Format) and JPEG (Joint Photography Experts Group). Also, each image program will normally use a proprietary file format, such as PSD for Photoshop or PSP for Paint Shop Pro. Digital cameras may also use proprietary versions of the RAW, TIFF or JPEG formats. The RAW format is used to provide a saved image file that is the raw data captured by the camera without any internal software manipulation. The RAW format is the choice for serious users.

The type of file format used can normally be determined by examining the filename extension added by the program, for example, myFile.psd, myPicture.jpg or myHome.tif.

Most file formats use some form of data compression to reduce the final storage needs of the image. Compression algorithms are either 'lossless', which means all image data is retained intact, or 'lossy', meaning some image data is allowed to be lost to increase the amount of compression (known as the compression ratio). Lossy compression should be used only on a copy of your master image file since it will slightly degrade the image quality. One of the best 'lossy' formats is JPEG, which provides various degrees of compression, allowing you to select the best compromise between file size and image quality. However, always keep the master image in either TIFF or PSD format.

Capture method

Final digital image quality depends on the quality of the image at every stage, starting with the way the digital file was originated. Before digital cameras offered sufficient image quality to be taken seriously, the only way to obtain a digital file was to scan either a film or a print original. For larger film format users scanning is still really the only option, since large-format digital camera backs are much more expensive than a good-quality film scanner. For 35 mm users the situation is more flexible. Due to the rapid improvement of 35 mm digital cameras, users of this format can choose their preferred method of originating digital images.

Digital cameras

It may seem a straightforward decision that using a professional digital camera is the best option for serious 35 mm users but let's think about it for a moment. The advantages of using a digital camera are obvious: it is just like using a traditional camera, the image can be transferred to the computer quickly, less cleaning up of the

basic image is needed, and the image is often less grainy. However, there are disadvantages too: the file size cannot be increased without loss of quality (this is the main problem); the effective contrast range is much less than that of black and white film for maximum future use the image must be captured at the highest-quality setting, resulting in a large image file; a digital file can become corrupted unintentionally; computer storage methods change, making archiving a problem, with no guarantee that the files will be accessible in the future. These points should be carefully considered before abandoning your film cameras and fully committing to digital 35 mm.

Film/scanning

Of course, using film also has disadvantages and these haven't changed. Large-format users have little choice but to use film (unless they can afford a LF digital back), but even 35 mm users should reconsider the advantages. One of the important decisions a creative photographer has

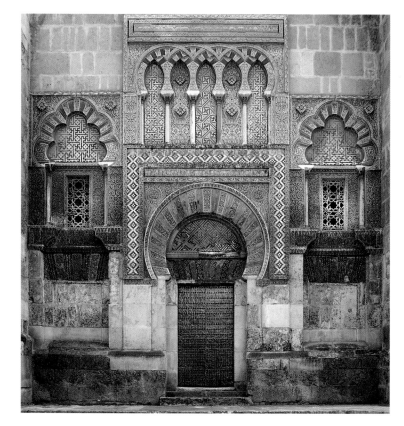

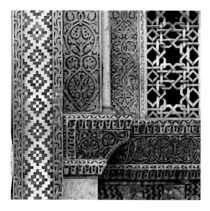

Mosque gate
This picture was made using a Fuji S2 Pro 35 mm digital camera and a wide-angle zoom lens. The image was originally saved in RAW format and subsequently manipulated to correct convergence and the inherent reduced sharpness of digital capture.

Mosque gate – unsharpened section
This section from the original image shows the lack of crisp sharpness that is an inherent feature of 35 mm digital images.

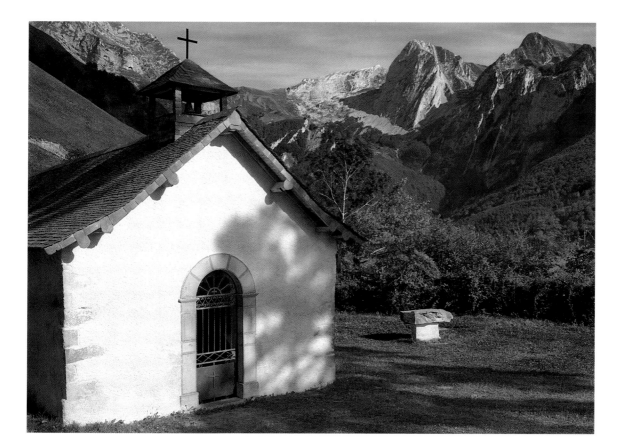

Chapel, Pyrenees

This picture was scanned from a 5 x 4 in black and white film negative. The negative was actually unprintable using traditional darkroom methods due to accidental severe over-development, which caused the white wall to be blank white in a print. With the excellent density range of a modern film scanner, I was easily able to produce a high-quality digital image that retained full detail in the white wall.

Chapel – unsharpened section

This section of the original unsharpened scan clearly shows the vast difference in inherent sharpness of a film scan compared to a 35 mm digital camera image.

to make is which film will deliver the image characteristics that the intended picture demands. Experienced photographers know that different films and printing papers produce different final print qualities. Often these individual qualities are hard to define but are there none the less. These material qualities of traditional photography are largely lost when using digital cameras.

Another advantage of film, especially for large format, is the ability to match the density range of the negative to the subject brightness range (using the zone system). Although different subject brightness ranges can be dealt with digitally, it requires time and experience to achieve the best results. Due to the wider exposure range of film over digital, it is still better to control negative density range in processing and then scan the film.

The other main advantages of film are: easy and safe archival storage, film can be rescanned to replace lost image files, and as scanner quality improves film can be rescanned with higher quality to produce bigger image sizes.

The main problems with scanning, especially for 35mm film, are that scanning tends to emphasize the grain of the film as well as the inevitable dust/scratches, which leave artefacts that require retouching. The methods used by the scanning software to reduce these problems unfortunately also tend to reduce image sharpness slightly.

Lens quality

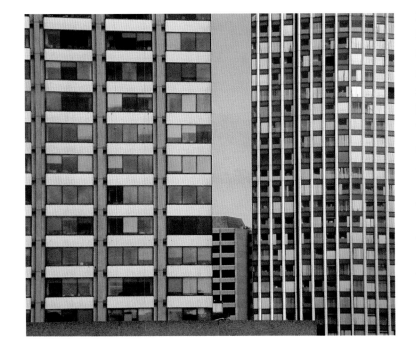

Image shape distortion

This picture of buildings contains lots of parallel lines and shows any image distortion quite clearly. I used a long telephoto lens, which has produced noticeable pin-cushion distortion. Fortunately, this can now be corrected using image software. I have selectively coloured the buildings to simulate golden evening light.

It has always been important for image quality to use the best lenses possible and to use each lens at the optimum aperture for depth of field and image sharpness. This criterion for best image quality from a lens applies especially to 35 mm digital cameras, since the method of capture produces inherently soft images. Unfortunately, with the profusion and convenience of zoom lenses, lens quality seems to have lost its importance for the vast majority of digital camera users. However, for the serious user it should still be of prime importance to use the best fixed focal length lenses you can afford. Of course, even the best lens in the world won't produce a sharp image if it is badly used. For best results, always use a tripod where possible and focus manually and carefully.

Lens aberrations

One of the factors of lens design that has a direct bearing on your pictures is known as lens aberrations. Basically, lens aberrations cause some form of distortion of the subject in the image or the rendition of colour/tone. There are two main types of lens aberration that directly affect image quality: shape distortion and chromatic aberration.

The curvature of the glass elements in a lens causes the subject to be distorted in the resulting image. Wide-angle lenses tend to make the subject appear to bulge – an effect known as barrel distortion. Telephoto and long-focus lenses tend to make the subject bow inwards: this is called pin-cushion distortion. Imagine a telegraph pole near the edge of a picture. Barrel distortion will make the middle of the pole curve outwards towards the edge of the picture, while pin-cushion distortion will make it curve inwards.

These distortions are more pronounced with extreme focal lengths and are worst in zoom lenses. Of course, the creative photographer may wish to make use of distortions as part of the composition of an image. Alternatively, these problems can be corrected and/or created in your editing program.

Chromatic aberration

This highly enlarged corner section of an image shows quite clearly the chromatic aberration produced by a wide-angle zoom lens (a 17–35 mm). In this case it is the blue and yellow colours that are causing the colour fringe along the edge of this old painted wall.

Aperture test

To find the best apertures for a lens simply select a textured surface, as shown here, place the camera on a tripod (with a cable release attached) and make sure it is parallel to the surface. Focus carefully on the surface detail and make a series of exposures at each aperture. Examine the centre and corners of each frame (shown here in red).

The other lens design factor that has an impact on image quality is longitudinal chromatic aberration. Lenses intended for general photography are known as apochromats since they are required to focus the three primary colours of light at the same image plane. This is very difficult to achieve even with the best lenses. If chromatic aberration is present it will be seen as a colour fringe around details in the image, reducing both colour accuracy and image sharpness. If this is not corrected before a colour image is converted to greyscale, lines of a lighter tone will appear around the detail. This is dealt with in more detail later in the book.

The aperture

Most experienced photographers know that the aperture controls not only the quantity of light allowed to enter the camera and the depth of field (the area of acceptable apparent subject sharpness) but also the definition across the image plane. At wider apertures, e.g. f/5.6, the definition at the edges and corners of the image will be less than that at the centre. As the aperture is closed the difference between the centre and edge definition reduces until, at the optimum aperture for that lens, it is nearly impossible to see any difference. Closing the aperture further will not improve definition. The best aperture can be found with a simple test and is worth knowing.

Although the centre-to-edge definition is a serious issue, and is important to consider when buying a new lens, in practical work the choice of aperture should be based on the depth-of-field requirements of a particular picture. Note also that using a lens at the smallest aperture can actually reduce image sharpness due to diffraction – the bending of the light rays at the edges of the aperture.

Centre sections
This series shows the centre sections for the apertures f/4, f/8, f/11 and f/16 of a 17–35 mm wide-angle zoom lens. Note that the definition improves as the aperture closes from f/4 to f/8 but doesn't change much after f/8.

Corner sections
This series shows the corner sections for the same range of apertures, f/4, f/8, f/11 and f/16. It is clear that the edge definition is quite poor at f/4 and only really starts to match the centre section at f/16. Therefore, for this 17–35 mm zoom lens I need to use at least f/16 if I want good definition across the frame. This would severely restrict my choices when trying to produce the best quality images.

31

Tools and concepts

Flare

One of the commonest causes of image quality degradation at the camera stage is due to flare. Flare is the term used to describe any non-image-forming light that may enter the lens.

Direct and indirect flare

Flare can be caused either indirectly, by bright sources outside the picture area, or directly, by the refraction of light through the aperture from a bright source in the picture. Indirect flare tends to add unwanted light in the darker parts of the image, causing them to become lighter than expected. This results in reduced contrast in the image and weak shadows. Direct flare is created when light from a very bright part of the image either causes diffraction as it passes through the aperture or produces internal reflections between the elements of the lens. The first causes an object to glow and spread light into other areas, the second and more common is usually caused when the sun is included in the picture and can be seen as repetitive images of the shape of the aperture. The latter effect is often used creatively with pictures including the sun (since it is difficult to avoid anyway).

Indirect flare is easily avoided by the use of a proper bellows-style lens hood on the lens, extended to the maximum distance for the focal length in use. Sometimes, if the sun is just outside the picture area, it may even be necessary to prevent light entering the correctly set bellows by holding something between the bellows and the source of the light (I find a hat or a piece of black card very useful). The small rubber lens hoods sold with lenses are almost useless for good flare prevention and should be used only if nothing better can be found (a wide sun hat is better).

Flare and digital cameras

Since the recording medium of digital cameras cannot record anything brighter than a 'white' value of 255, areas of direct flare usually cause 'white-out'. Unlike traditional film negatives which can often be made to reveal detail in over-exposed areas, digital white-out is beyond recovery and results in ugly blotches in the image. The solution is to make different exposures, if possible, and combine them later in an editing program.

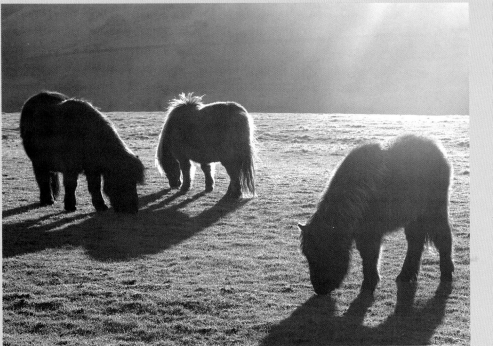

Off-camera flare

This picture shows the typical result of having a bright source of light just outside the picture. The flare from the sun has caused all the dark tones to become too light and reduced the overall contrast of the scene. The histogram screen shot shows how the tones have been affected.

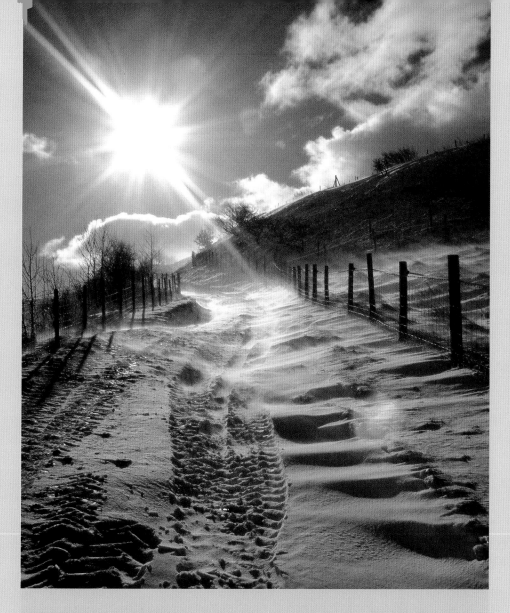

Blowing snow

With the sun just off centre, this picture shows the typical flare effects created when there is a bright light in the subject. Internal reflections of the aperture shape on the glass elements have produced light patches around the sun and in a diagonal line from the sun to the bottom right corner. The starburst effect is caused by the size of the lens aperture (smaller apertures produce more starburst). Also, the area around the sun is showing the white-out effect caused by gross over-exposure. Although technically these are faults, the overall visual effect they have created adds to the drama of the shot.

Camera lens shaded

With the lens well shaded with a piece of black paper, the extraneous light has been eliminated and the contrast and tones are now as expected. The actual camera exposures for this and the flared version were identical. The histogram shows the corrected tonal distribution. Compare this to the flared version.

Colour theory

It may seem odd to have a section on colour theory in a book on black and white photography, but since we are dealing with digital editing, which even with mono images will often be used in colour mode, a basic knowledge of colour will prove to be important. For digital exponents it is necessary to understand colour in terms of both light and pigment, because you will usually be dealing with both aspects.

White light, and any neutral grey tone, is composed of equal quantities of the primary colours red, green, and blue. All other colours of light can be produced by adding various unequal quantities of the three primary colours. Mixing colour with light is known as 'additive synthesis'. Photography is based on additive synthesis and this applies to digital imaging too. Digital files are usually in RGB mode during editing and each pixel displayed on the monitor has a red, green, and blue component. When each colour component has a value of 255 the displayed pixel is white. Conversely, when each colour component has the value 0 the displayed pixel is black.

When an image is to be printed in a magazine, a book or on a poster, the printing industry uses pigmented coloured inks to create the image on paper. The three colours used for pigments are yellow, magenta, and cyan.

Additive and subtractive colour

These illustrations show how primary colours interact to form other colours. The first example on the left shows how additive synthesis forms white light. Where two primary colours mix the complementary (or tertiary) colour is formed, e.g. adding the red and green primaries of light makes yellow. In the subtractive synthesis system used with pigment colours (right) the primary colours are yellow, magenta and cyan. The tertiary colours are thus red, green and blue.

The various shades and tints of a particular colour, e.g. dark red or light pink, are formed by either adding or removing black or white respectively. In the additive system of light this can be achieved by varying the intensity of a filtered light. The gradations of colour beneath each set of colour circles shows some of the shades and tints possible.

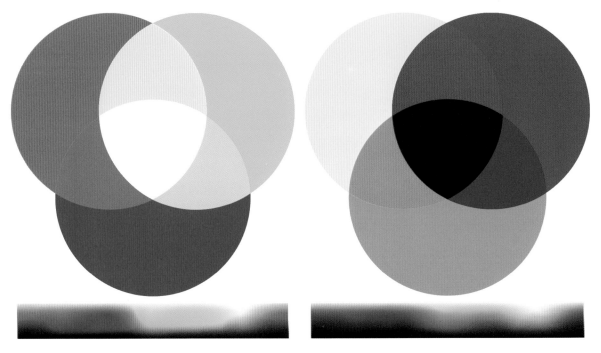

Going home!

This picture is a full-colour RGB image. Since I recommend in this book that digital camera users use the full-colour mode when making images it is useful to understand exactly what RGB means.

Greyscale version

When you convert a full-colour digital image to black and white (greyscale mode) using the channel mixer method, as I did here, it is necessary to know how additive colour is formed so that you can appreciate how the channel mixer works.

Duotone version

In the printing industry it is normal practice to convert black and white pictures to duotone so they can be printed using a range of coloured pigments to improve the final printed image. As here, duotone is used to apply toning to an image.

Pigmented inks are known as subtractive colours because as white light strikes the colour some of the wavelengths are absorbed, or subtracted, in 'subtractive synthesis'. In theory, pure yellow, magenta, and cyan pigments should combine to absorb all light and produce black. In reality, due to impurities in real inks, the result is a muddy brown colour. To overcome this problem black ink is used as a 'key' colour (hence the CMYK colour mode) when producing full colour images on paper. It is normal practice to use coloured inks, rather than grey inks, which are shades of black, when reproducing black and white pictures in high-quality books to increase the resulting tonal range and create more beautiful prints. This process is known as duotone, tritone or quad-tone, depending on the number of different ink colours used. In a similar way, home inkjet printers use CMYK coloured inks to produce photo-realistic pictures.

When editing black and white images it is often advantageous for the file to be in RGB mode to allow toning and other effects to be applied. When a black and white picture is in RGB mode the editing program treats it as a colour image.

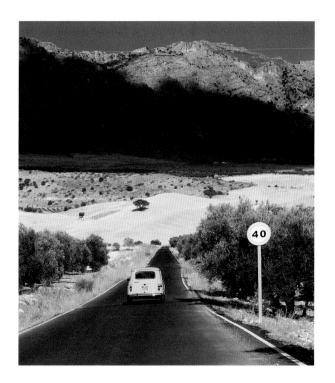

Surreal colour

The channel mixer can also be used to apply unusual colour effects to the image. In this version, I experimented with the individual RGB colours to create a slightly surreal rendition. Paradoxically, knowing about colour is vital in the digital world of monochrome.

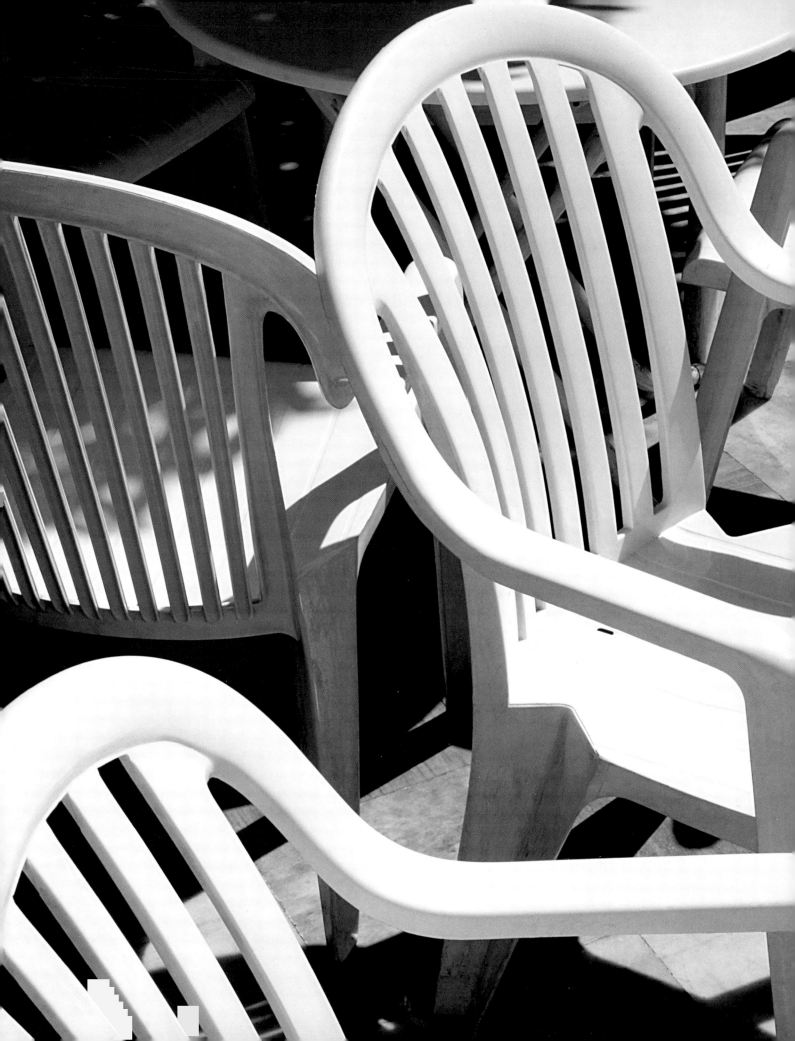

Chapter 2
Cameras and scanning techniques

In this chapter we examine the essential practical skills and techniques that will help you to obtain the highest-quality digital file from which to begin your creative explorations. If you are new to digital photography, many of the practical tips and techniques in this section will widen your knowledge of photography and help you produce more consistent images at the camera stage.

We start with a look at equipment calibration as it relates to the creation and viewing of the original digital file. In traditional photography, equipment calibration has always been considered a rather tedious but ultimately essential practical first step to obtaining top-quality film negatives and prints. This has not changed! In fact, it is more essential than ever before to have your digital equipment calibrated, as far as possible, to enable you to obtain any sense of consistency in your digital work.

The calibration topics are followed by a reasonably detailed look at some practical camera techniques, such as camera quality settings and digital zone system. Some of these techniques apply only to digital cameras but most of them, with some adaptation, can also be applied to traditional film cameras. It is essential to cover some of the basic aspects of picture making for newcomers to serious photography, such as exposure control, and these may appear to be irrelevant to more experienced practitioners (but read them anyway – you never know!).

The last part of this chapter explores the practical aspects of film scanning and how to obtain the best digital file when scanning monochrome negatives. This section is for those many people arriving at the digital threshold with cabinets full of monochrome film negatives just waiting to be revisited in a new, creative way.

Café chairs – Antequera, Spain (opposite)
Only by calibrating your equipment can you hope to control your picture making.
By understanding the limitations of the camera and using intelligent exposure
control, you can capture any subject in the way you wish.

Monitor calibration

The item that requires calibration before anything else in the system is your computer monitor. If the image you see on the screen is being displayed incorrectly, because the monitor has not been calibrated, you will always have problems. Before starting to calibrate a CRT monitor make sure it has been switched on for at least 20 minutes to allow it to stabilize. Also, monitors change over time, so it is a good idea to check the calibration at least once a month.

The simplest way to calibrate a monitor is visually, using a software calibration tool such as Adobe Gamma (Windows) or Monitor Calibrator (Mac OS). The visual method is dependent on your own ability to judge what is being displayed and inevitably is not the most accurate system.

The most accurate method of monitor calibration uses a combination of hardware and software (which removes the possible human error). A colorimeter is used to read a displayed set of known colours directly from the screen. These colour values are then converted into a profile by special software. This method is very accurate and is essential for professional use.

Using Adobe Gamma

If you use Adobe Photoshop, a utility called Adobe Gamma will have been installed on your Windows machine and an icon placed in the control panel. You can use the wizard to step through the calibration process or work manually. The easiest method is to start Adobe Gamma from the control panel and work through the wizard.

Before calibration, set the background colour of the desktop to a mid-tone neutral grey colour. A colour desktop will distort the calibration process.

Monitor brightness and contrast

The first step when using the monitor calibration program on your system (e.g. Adobe Gamma utility) is to set the contrast of the monitor to maximum using the monitor's own controls. Then open the utility and adjust the monitor brightness control until you can only just see the patches shown in the Brightness and Contrast section of the dialog. The two screen grabs here show the before and after dialogs. Set the Phosphors, Desired Gamma and White Point according to your monitor technical sheet or use the settings shown here.

Adjusting gamma

Gamma is a measure of the difference in value of a range of tones. For the monitor the single gamma slider will adjust the mid-range values of the screen. To adjust this slider, half-close your eyes and watch the small square as you adjust the slider. When the design blends together the gamma is set. The screen grabs show the difference the gamma makes to the display.

Adjusting colour balance

By clearing the View Single Gamma Only check box, you gain access to the individual gamma sliders for the primary colours red, green and blue. If your grey desktop background seems to have a colour cast correct it here in the same way as the grey gamma.

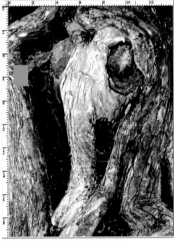

Display comparison

These screen images show how the same image will look on a monitor with a green cast and on the corrected monitor.

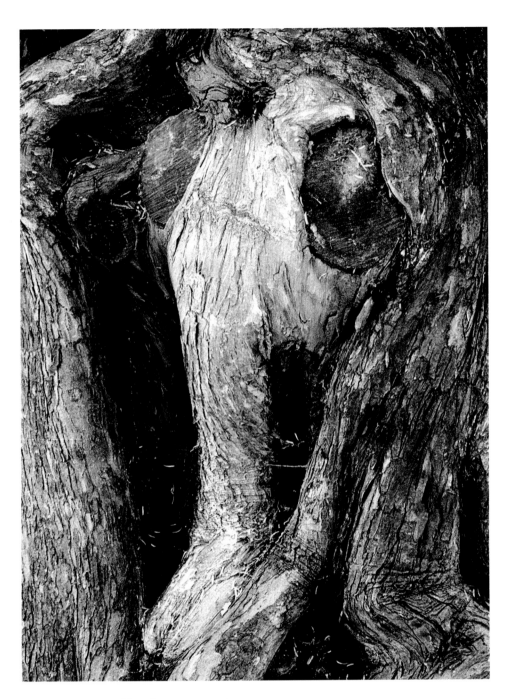

Using a colorimeter

Display the image of an IT8 colour test target on the monitor. Using the colorimeter read each colour value into the software and process the readings to make the profile. Apply the profile using either the Windows or Macintosh colour management system. Specific manufacturers' instructions will be provided with each individual colorimeter device.

Tree hag

The importance of monitor calibration becomes clear when you want to tone a black and white image, as shown here. Any colour cast introduced by an uncalibrated monitor will make it very difficult to assess the toning colour accurately. This is especially important when you try to print the picture.

Camera calibration - determining the texture range

Experienced photographers understand the importance of knowing the 'texture range' of their chosen medium, whether it is film or digital. This is the number of stops of exposure at which a textured object can be recorded at whilst retaining its detail. Knowing the texture range allows you to predict how the various brightness values of a scene will record in the image, and especially whether parts of the scene will record as featureless white or pure black in the final image.

Increasing the exposure of a subject will lighten the metered area, while reducing the exposure will darken it. This is the essence of a concept in the zone system known as 'visualization', which can be used just as well with a film or digital camera.

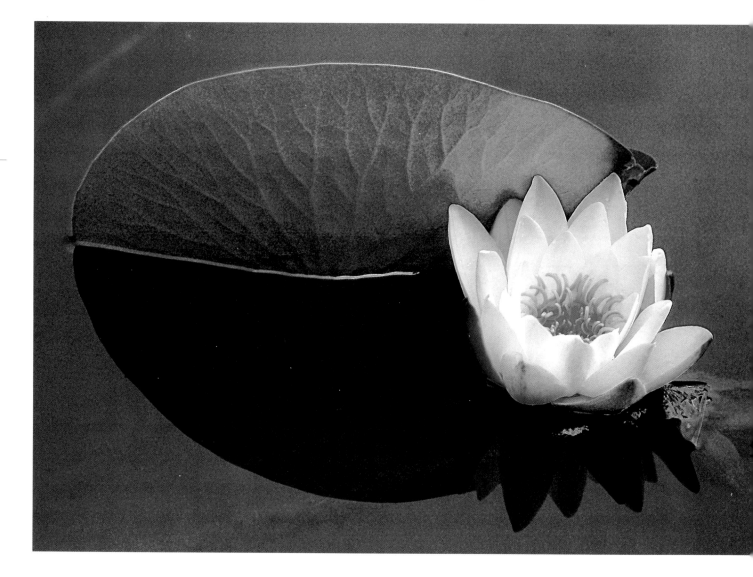

Water lily

High-contrast subjects require accurate assessment of their tonal range
to ensure that detail is retained in both the shadows and the high values.
This is possible only if you know the texture range limits of your camera.

Preparation for testing

The test requires you to make a series of 22 different exposures of an evenly lit textured subject such as the middle grey rectangle on the home-made target shown overleaf. Each exposure will be one half stop different from its neighbours. This will produce a texture tone scale that will show you how well the camera records texture at various exposure levels. It is important that the light on the subject remains constant throughout the test, otherwise the exposures will not be relative to each other.

Position the target in direct sunshine so that you can clearly see the texture. Fill the viewfinder with the target and focus so the texture is sharp (a tripod is recommended). Set the camera to its highest-quality settings and to manual exposure mode (for auto-only cameras use exposure compensation or change the film speed to make changes to the exposure).

Testing the dark tones

Set the aperture to f/4 and take a light reading from the target adjusting the shutter speed to obtain normal exposure. If you are using my painted board idea, meter only from the grey area in the middle. Make a note of the settings. *Do not meter the card again.*

Make one exposure: this is the normal exposure. Close the aperture to between f/4 and f/5.6, a half stop reduction in exposure, and make a second exposure. Continue reducing the aperture in half stop steps and exposing until you have made a total of 11 exposures (the final aperture will be f/22 if you started on f/4). This will produce a sequence of images that get progressively darker.

Testing the light tones

Now you need to produce a series of progressively lighter images of the target. Set the aperture to f/22 (or f/16 if that is the lowest) and meter the target again. Use the shutter speed to obtain a normal exposure as indicated by the camera, and make this normal exposure. Without metering again, open the aperture by a half stop (i.e. between f/16 and f/22) and make another exposure. Continue opening the aperture in half

Short texture range subjects

With low-contrast subjects where the tones are fairly similar, as shown here, only a part of the texture range is used. This means you have a choice, controlled by the exposure, of where you wish those tones to be on the texture scale. This allows you to change the mood of the image. As you can see by the histograms for the two images, changing the exposure simply moves the tones along the graph without losing detail at either end. This is not possible with high-contrast subjects that fill the texture range, because the exposure is much more critical (see the sunflower overleaf).

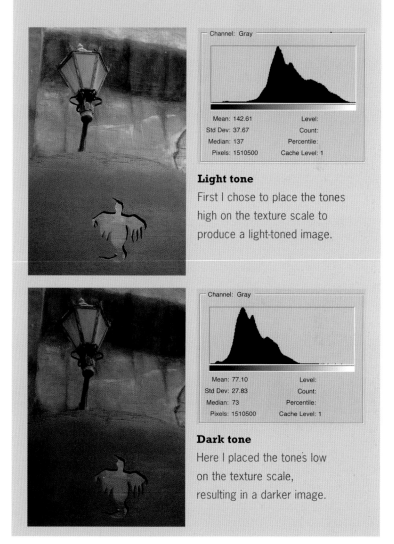

Light tone
First I chose to place the tones high on the texture scale to produce a light-toned image.

Dark tone
Here I placed the tones low on the texture scale, resulting in a darker image.

stop steps and exposing until you have completed 11 different exposures. If you started at f/22, the final aperture should be f/4.

Checking the results

You now have a total of 22 images, covering a wide range of light and dark exposures of the

Making a test target

To determine the texture range of a camera you need a finely textured test subject. Any neutral-coloured textured subject will do, but since I need a standard target quite often I made a permanent one using an A2 sheet of hardboard. To remove the wood colour and make the target useful for other tests, paint the rough-textured side with black, white and grey matt emulsion paint as shown. I mixed black and white paint to make the grey match the 18% reflectance tone of a Kodak grey card. Although this target contains areas of black and white these are not utilized for the texture test but will be useful in other tests.

Low-value texture

This series shows exposures for the dark tones. Texture can clearly be seen as low as zone II. This is similar to the way in which photographic film responds to texture.

High-value texture

This series shows the exposures for the light tones. The texture is maintained as far as zone VII (i.e. two stops above the meter reading) but by zone VIII pure white is obtained. This is slightly less texture than photographic film can record. If texture is required, it is essential that light subjects (e.g. snow in sunshine) receive no more than two stops above the meter reading.

same target. After downloading the images to your computer, use your image editing software to open the first 11 images, and closely examine each one at full size. Note the darkest image in which you can still see the texture pattern. You may notice that one of the darkest images shows 'noise' but not the actual pattern – this is not real texture. The darkest image to retain the texture shows how far you can reduce the exposure for a subject area before it is recorded as completely black.

To check the light tones, open the next set of 11 images and amongst them find the lightest image in which you can still see the texture pattern. An area that is pure white is outside the texture range.

The darkest and lightest images that show the texture pattern provide the limits of the texture range for that camera. You now have the knowledge to meter different areas of a subject and, by comparing the readings, predict how those areas will look in the final image.

Sunflowers (opposite)

Unusual lighting, such as the backlighting in this view of sunflowers, requires careful exposure measurement. If you understand the camera's texture range the correct exposure is easily determined.

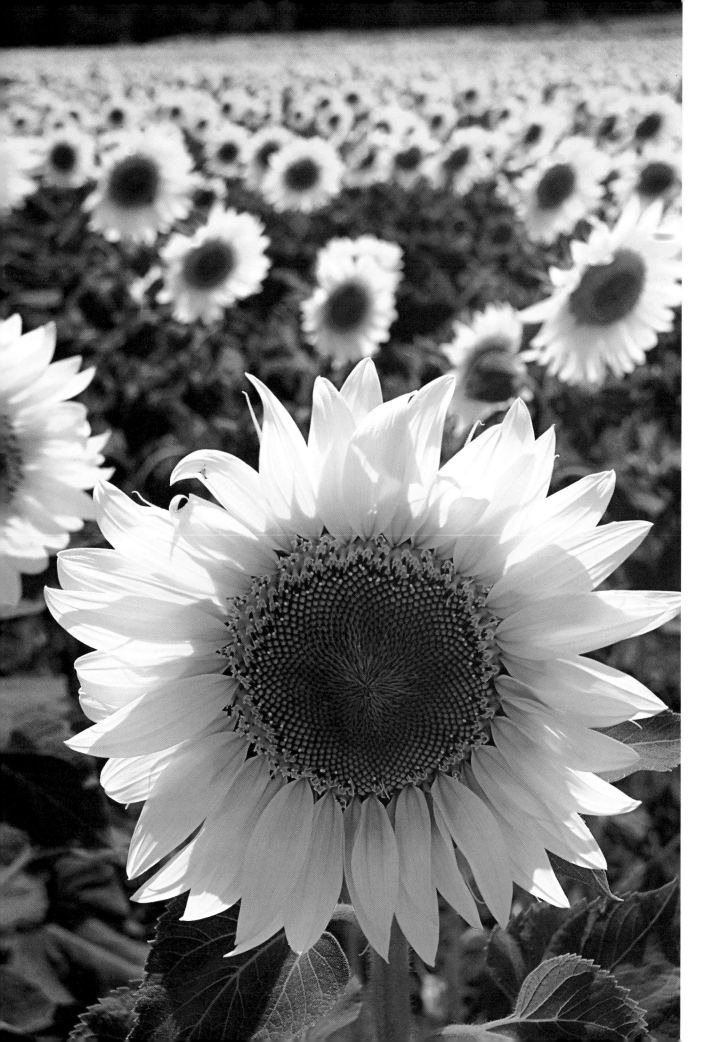

Scanner calibration

As with other digital equipment, each individual scanner produces colour in a unique way and needs to be calibrated to obtain the most accurate results. As usual, it is best to use a suitable IT8 test target. For flatbed scanners the original target will be printed on photographic paper. Film scanners require an original film IT8 target made using the specific types of photographic film that you use.

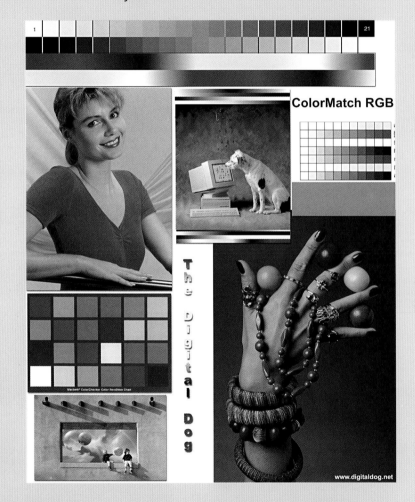

1 Digital Dog test target

This is the test target I used for the calibration tests in this book. It provides all the necessary colours and tones you need for visual calibration of your system. To calibrate the scanner for black and white prints (the method is the same for a test black and white negative, which is easy to make using items like those in this target), I converted the test target to greyscale and made a print from the file.

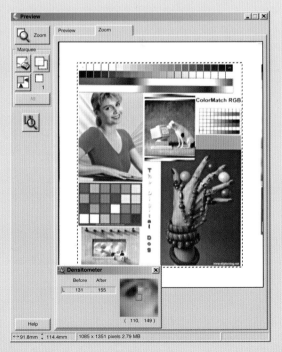

2 Scanner settings

With the print of the test target (or a negative) in the scanner open your scanner software and preview the target as shown here, using the default automatic settings. Set the scan parameters for a black and white image and the resolution as required. Crop the area to be scanned and make the first scan.

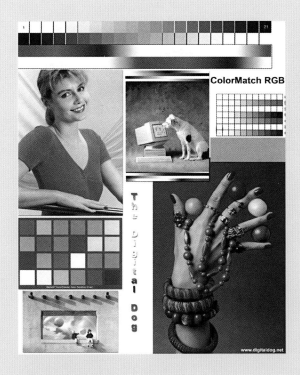

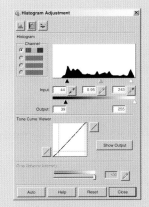

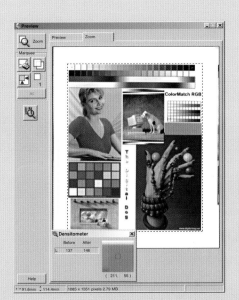

3 Unmodified scan

Here is the result of the automatic scan. The image is too light and too low in contrast compared to the original. This shows the scanner definitely needs calibrating.

The target is first scanned using the scanner's default colour and contrast settings, and the resulting image is displayed on a calibrated monitor. For optimum results, the colour values are then read from the screen using a colorimeter and processed into a scanner profile. Alternatively, the image can be printed on a calibrated printer using your preferred paper and ink media and compared directly with the original. The controls available in the scanning software can be used to adjust the scan to obtain an accurate result. These settings can then be saved as a scanner profile for regular use. Of course, for calibrating a film scanner the printing method is not very convenient since it is not easy to compare the printed result with the film original. As with other visual assessment methods, it is fraught with possible inconsistencies.

In the absence of a calibrated IT target you can make a reasonable calibration by printing the test target shown here, which is downloadable free from www.digitaldog.net. Of course, you need to calibrate your printer first (see pages 114–115).

4 Modifying the settings

To calibrate the scanner I used the Histogram Adjustment dialog shown here. By carefully monitoring the grey patches in the target with the built-in densitometer and adjusting the Input and Output sliders for each area of the histogram I was able to obtain a reasonably good scan. The preview screen grab shows the densitometer measuring the middle grey patch. Once the settings were satisfactory they were saved for future use.

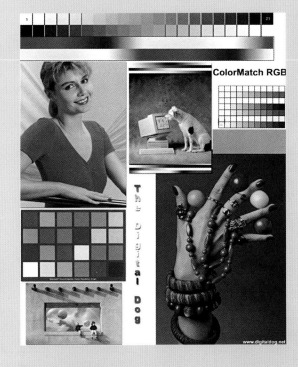

5 Corrected scan

This is the final scan using the calibrated values. Although not a perfect match with the original (which is probably a utopian dream anyway) it looks reasonably good. As you scan more originals you may determine that minor adjustments are needed to the calibration settings to fine-tune the system over time.

Choosing the right quality settings

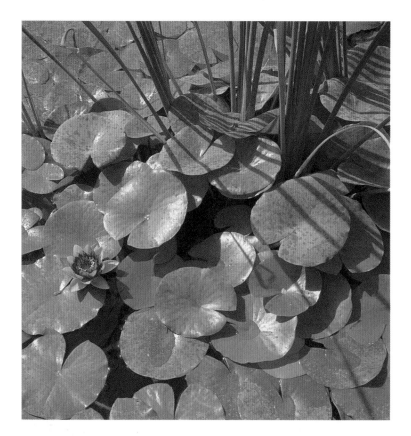

Ignoring the optical quality of the lens, the image quality produced by a digital camera is a combination of the recorded pixel dimensions, the compression method used when the image is saved, and the sophistication of the camera software. (Of course, this list excludes bad practice on the part of the user.)

To cater for different user requirements, all serious digital cameras have a range of quality settings from which to choose. The settings for a particular subject will depend on how you intend using the image. For serious photography and to provide the maximum flexibility later you should choose the highest pixel dimensions the camera permits (without interpolation) and a lossless compression option. Professional-level cameras will provide the maximum quality saving the image in the RAW file format since with this the image data does not have any changes made to it by the camera software. This will provide the 'purest' image file for later manipulation.

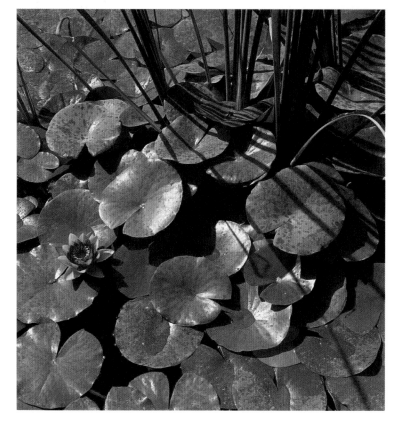

RAW settings (left)
These two images are from the same camera RAW file. They show that by simply changing the settings in the RAW converter when opening the image in Photoshop different results are obtainable. Since the converter is using the raw image data you retain the highest quality. This flexibility is not possible when the camera image is saved in other formats.

Fine mode JPEG (opposite)
This image was shot with the camera set to its highest pixel level of 4256 x 2848 and the compression mode set to 'Fine'. The camera saved the image as a JPEG. Using these settings produces good quality but is not as flexible as using the RAW format.

Exposure control

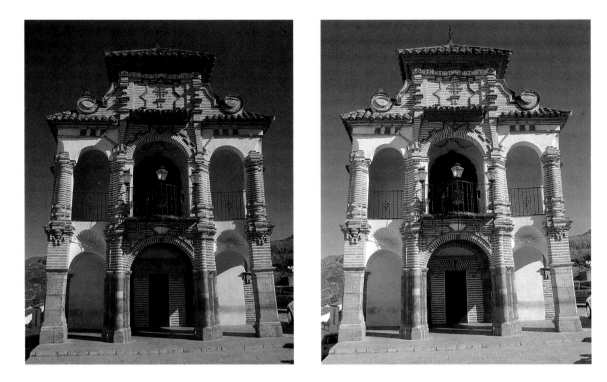

Exposure control

As shown in this sequence, increasing or reducing the total exposure of an image lightens or darkens the whole scene. If you want to change either the aperture or shutter speed for creative reasons it is necessary to change the other control equally to maintain correct exposure.

The term 'exposure' is used to define the total quantity of light allowed to enter the camera lens that is sufficient to produce the desired image of a particular subject. There is no such thing as one 'correct' exposure for a given scene. The correct exposure may be different for two different photographers, recording the same scene, since exposure is a function of visualization (how you want to interpret the subject). Therefore, it is better to refer to the 'optimum exposure' for a scene, which will be the exposure that produces the result you desire. Of course, if the result is not what you intended – if it does not fulfil your visualization – then you have made an error of judgement and produced a less than optimum exposure.

To determine the exposure for a scene, use the camera's built-in light meter set to spot mode (or a separate meter) to measure the various

brightness values in the scene and decide in which of these you want detail to appear. See the Digital Zone System section (pages 58–63) for more detail.

A single exposure is a combination of the quantity of light passing through the lens aperture and the amount of time that the light is allowed to act. The formula is: $E(xposure) = I(ntensity) \times T(ime)$. The intensity of the light is controlled by the size of the lens aperture, while the time is controlled by the shutter speed. Smaller apertures, e.g. f/22, reduce the intensity of light and wider apertures, e.g. f/5.6, increase it. Similarly, fast shutter speeds reduce the time the light is allowed to act and slower speeds increase it. These two values are reciprocal so, to maintain the same level of exposure, if you increase the intensity (by opening the aperture) you must reduce the time by a corresponding

amount (by changing the shutter speed). The shutter speeds and aperture values marked on cameras and lenses follow an internationally agreed system and are based on a doubling or halving of adjacent values (odd values are rounded as necessary).

For example, you use your camera light meter on a scene and it indicates that the optimum exposure for your visualization requires 1/125 sec at f/8. However, you decide you need f/16 to obtain the required depth of field. Changing to f/16 results is a reduction in intensity of the light entering the camera of two stops. To compensate for this change, and return the exposure level to that required, it will now be necessary to increase the time by the same amount of change (two stops). Adjusting the shutter time to compensate, the final camera settings will therefore be 1/30 sec at f/16.

Shutter speed and movement

The shutter speed can be used to control subject movement. In the example shown here, the first image was exposed for 2 sec and the second for 8 sec. In the longer exposure, I have utilized the longer car light trails to produce a stronger compositional line in the foreground of the image.

Using digital film speeds

Film speed, as understood by experienced film-based photographers, does not really exist in the digital world. However, a camera without film speed settings would probably never sell, so camera makers have devised a method of simulating a film speed system by adjusting the electronic gain (sensitivity) of the image capture device. However, the range of speeds offered by this method is more restricted than with photographic film due to the limitations of the electronic devices. Also, digital capture devices do not provide the type of inherent visual qualities traditional photographers have become accustomed to when using films of different speeds. This means that in practice a particular digital film speed is chosen purely to achieve the desired exposure settings rather than for the inherent visual qualities of the medium.

The biggest advantage of digital cameras with reagrd to film speed is the ability to set the

Twigs and grass

This picture was shot with the last light of the sun backlighting the grasses. Because the brightness of the light was quite low, it was necessary to use the fastest film speed of ISO 1600 to obtain reasonable exposure settings of 1/125 sec at f/11. Since using high ISO settings leads to slight degradation of the image details, I decided to select an aperture that would produce just enough depth of field for the centre of the subject, where the dead branches were.

desired speed for each individual image, something that is not possible with a roll of film. For example, if the light on a landscape is fading and you wish to retain the same aperture and shutter speed for several images, you can simply increase the digital film speed for each image as the light dictates. Of course, the quality of the image changes as the film speed increases, just as it does with traditional film.

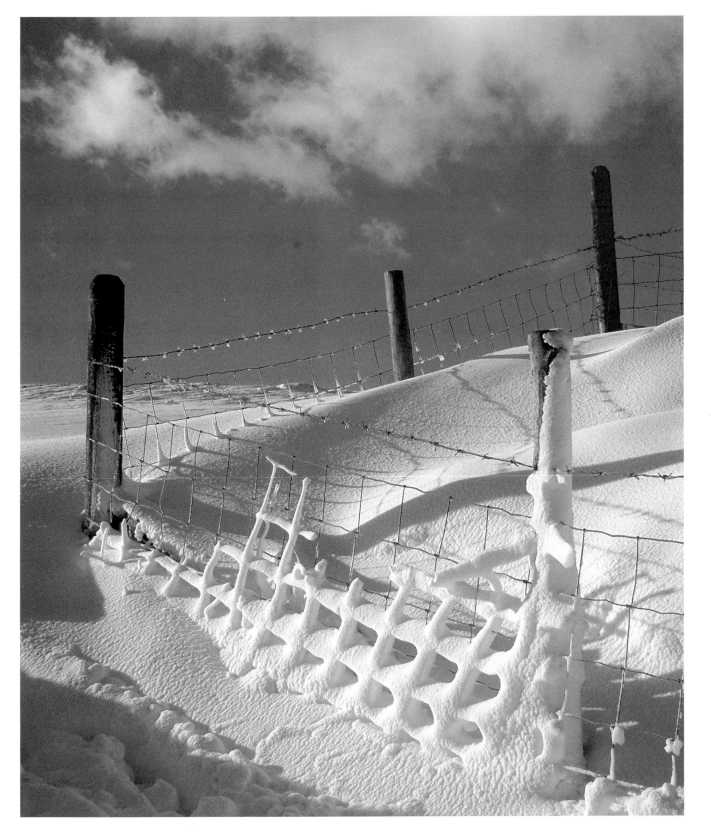

Posts in snow

When the light is very bright, as in this snow scene, it is best to use the
slowest film speed to obtain the best quality. This is especially important
when the subject contains fine detail such as the snow texture seen here.

Focus and depth of field

Old wire screen

The close position, use of a normal lens and a medium aperture has allowed me to control the depth of field in this picture. I wanted to provide a sense of place for the screen but also retain some differential focus to make it stand out from the background. This has been achieved by retaining recognizable details, but with reduced sharpness, in the background.

An important aspect of any photograph is where the subject is critically sharp and how much of the scene is acceptably sharp. The perception of image sharpness is quite subjective as it can be influenced by factors that are not constant or predictable, such as how good a person's eyesight is. Lens quality and how the camera is also used have a strong influence on the eventual image sharpness. For this reason photographers often use the expression 'acceptably sharp' when discussing image sharpness.

Critical sharpness occurs only at the plane of focus and this is determined by the distance at which the lens is focused – a lens focused on a point 2 m away places the plane of focus at that distance. Also, assuming no large-format camera movements have been used, this plane of focus is parallel to the image capture plane.

The area of acceptable sharpness is determined by the depth of field, or DoF. DoF refers to that portion of the image, from a point near the camera to a point further away, that is considered acceptably sharp. Basically, the unsharp parts of the image are outside the DoF. Depth of field is controlled primarily by the aperture (e.g. f/22 produces more DoF than f/8), but the distance of the subject from the camera and the focal length of the lens also influence the amount of DoF. For a given aperture, as the camera moves closer to a subject the DoF decreases.

Wide-angle lenses cram more of the subject into the picture, which in turn makes everything in the image smaller. This also makes everything look sharper and hence produces more of that acceptable sharpness, or DoF, I keep mentioning. Longer lenses have the opposite effect. Long focal length lenses also tend to exaggerate any minor camera movements due to the increased magnification of the subject, and this also reduces sharpness (although it does not strictly affect the amount of DoF).

Maximum DoF for any aperture is achieved when the lens is focused on the hyperfocal distance. The hyperfocal distance is the distance from the lens beyond which everything appears to have the same sharpness. The hyperfocal distance reduces as the aperture is closed, resulting in more DoF. For practical purposes, if you want maximum DoF close the lens aperture fully, e.g. f/22, and focus the lens on the hyperfocal distance for that aperture. If your lenses have a DoF scale engraved on the barrel you can set the hyperfocal distance for any aperture simply by aligning the infinity distance mark opposite the f/number in use (this is not 100 per cent accurate but close enough).

Use of a good tripod is very important for obtaining optimum sharpness and controlling DoF, as it allows you to focus the camera lens very carefully and then choose any of the apertures available for the desired DoF. This is not possible if the camera is hand-held due to the need for a fast shutter speed to avoid camera shake (the biggest killer of image sharpness). Also, due to the vagaries of most auto-focus lens systems, I recommend only manual focus for serious image making.

Wall and temple – Spain

In this picture I wanted as much sharpness as possible and so elected to use a wide-angle lens and a small aperture of f/22. By pointing the camera slightly down and focusing on the hyperfocal distance, the plane of sharpness was positioned to make the most of the depth of field. The convergence created by the camera angle was corrected later in Photoshop.

Solving depth of field problems

Before professional-quality digital cameras came into use, a common problem for a photographer using a film camera was how to obtain sufficient depth of field for a particular scene. Although DoF is mainly controlled by the aperture used, simply closing the aperture to its smallest size, e.g. f/22 or f/32, is not always the obvious answer it appears to be. It is well known that the smallest apertures may actually reduce image sharpness due to diffraction. There is also the matter of movement in the subject to be considered when selecting the aperture, because of the reciprocal effect this has on the choice of shutter speed.

Foreground focus (above)
This subject poses the problem of achieving sufficient depth of field to retain front-to-back sharpness with one exposure. Here, there are three main planes I wanted to be sharp; the tree knot at very front shown here in the lower right corner, the main curved branch in the lower half of the image and the trees in the distance. This is the first exposure, focused on the tree knot.

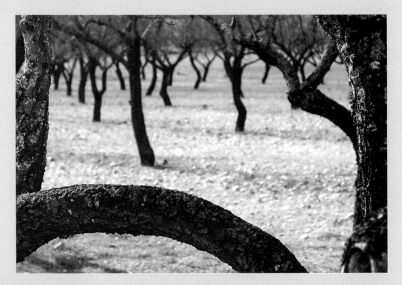

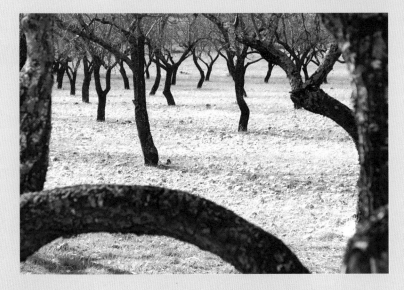

Middle sharpness (above)
For the second image I changed the focus so that the curved branch would be sharp. Unfortunately, my choice of aperture was not sufficient to hold the two upright trunks within the depth of field as well, so additional exposures were made with slight adjustments to the focus. These were later combined to form one image layer.

Distant sharpness (left)
For the last image I focused on the distant trees. One mistake I did make with this subject was to miss the fact that the tree branch behind the right-hand trunk was at a different distance entirely and should have received its own exposure. I needed to use local sharpening to correct this in Photoshop.

The holy grail of 'maximum DoF' is one of the reasons many people turn to the use of a large-format camera that offers camera movements. Camera movements provide the facility, using the rotations (or swings, as they are commonly called), of placing the plane of focus in the subject at an angle to the film plane. This, combined with a suitable aperture and focus distance, can produce enough DoF to give the impression of unlimited sharpness (this is in fact a myth; there is no such thing as unlimited sharpness). Of course, fixed-lens cameras cannot do this since the plane of focus is always parallel to the film plane, exacerbating the DoF problem.

Now, using digital methods, you can overcome this deficiency of film cameras and create pictures with all the DoF you desire. By making two or more images of the same scene from the same viewpoint, but with the camera lens focused on a different plane for each image, you can later combine them in an editing program to increase the apparent depth of field. Of course, this sounds too simple and in some ways it is, because there are problems with this method. The main problem is that when you change the plane of focus of a lens it also slightly changes the magnification of objects in the scene. This means that the objects in the scene in each of the images will be a slightly different size, and this needs to be corrected when editing. Other

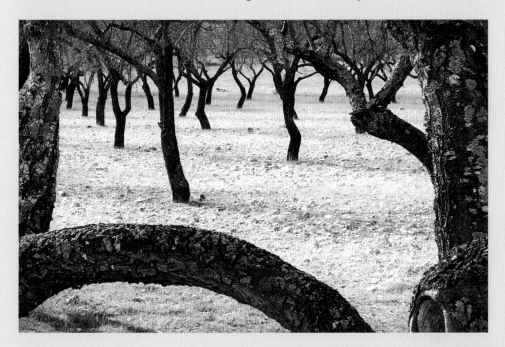

practical issues are that the camera must remain perfectly still, so a good tripod is essential, and that any movement in the subject can cause obvious problems.

Once the images are open in your editing program, copy them to separate layers in a new file and use layer masks to control which parts of each layer are to be seen in the final image. Using layer masks also allows you to use the clone tool to clean up any object size problems on the lower layers. Another useful aspect of this technique is that the different images could be given different exposures in the camera to help control the subject contrast. Any imbalance can later be adjusted using Levels or Curves adjustment layers.

Removing overlaps

The bottom layer normally requires the use of the clone tool to clean up any unfocused subject details that overlap the edges of the masked subject layers above. An example of this can be seen here as a darker blurred tone next to the edge of the lower half of the tree trunk (the upper half has been corrected).

Almond trees, Spain

The final image shown here is made up of five different images. The main branches at the sides and in the middle required three differently focused sections to be combined, although they are on only one layer here. The Layers palette shows the masked layers – note that the bottom layer isn't masked. The final touch was to tone the picture.

Dealing with high subject contrast

Contrast in the subject has always been one of the main technical problems facing film-based photographers, due to the inherent limitations of the silver-chemical photographic process. This problem is even greater when using digital cameras, due to the white-out effect described earlier (see page 32).

Fortunately, you can use the features of the editing program to overcome what was often a big problem. The method is straightforward: simply make two or more different exposures of the same scene and combine them using the layers in your editing program. This may sound like a no-brain activity but the creative photographer will apply some thought to the task in order to obtain optimum results.

First, determine the important subject brightness range, or SBR. The important range is where you want to retain subject detail, not areas that you want to be pure black or pure white. Ansel Adams called this the texture range of the subject. Once you know the SBR in exposure steps (or stops/zones), use this information in conjunction with the calibrated texture range of your digital camera to determine how many different exposures you need and what those exposures must be in order to capture the required textural information accurately. The simplest solution is the two-exposure method, with the first biased towards the lighter values and the second towards the shadow values. Of course, I am realistic enough to know that many people will simply 'bracket' exposures over a wide range, and this may have merits, but this book is for serious photographers who gain pleasure from participating in the mental process that is creative photography.

As is always the case with multiple exposure techniques, a good tripod will make the process easier to control and make later work less frustrating and time-consuming, as the images will align more easily.

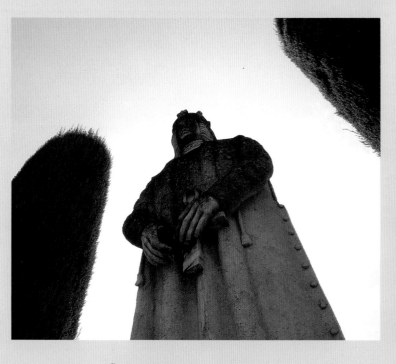

Statue exposure
The first exposure shown here was based on retaining details in the statue and foliage. The sky is rendered too light in this exposure.

Sky exposure
The second exposure was based on recording the sky to retain the subtle cloud detail. This exposure has made the statue very dark.

Combining the images

The first step is to copy the darker exposure to a new layer in the light image file. Then add a layer mask to the dark image and paint the statue and foliage area using a soft black brush. To speed this process, you can create a selection of the sky first, invert it and fill with black on the layer mask. Then clean up the edges of the mask if necessary. The Layers palette screen grab shows the finished layer mask.

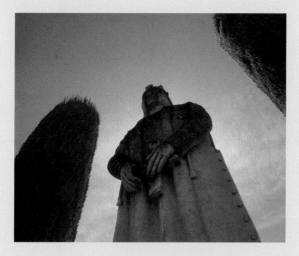

Royal overlord

The final image has had Levels adjustment layers added to change the tonal values of each of the image layers. I also added some film grain to the sky and darkened the lower right corner. The Layers screen grab shows the final arrangement of the layers.

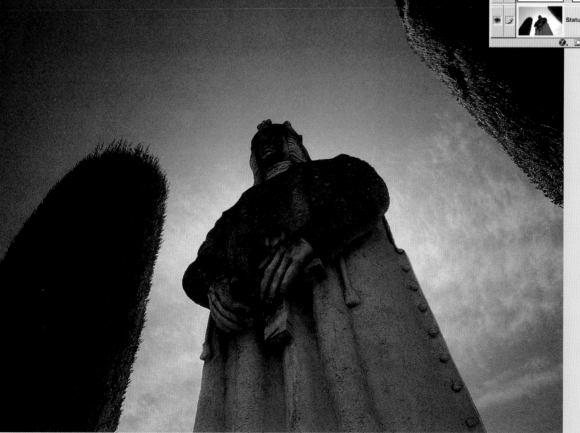

Digital zone system

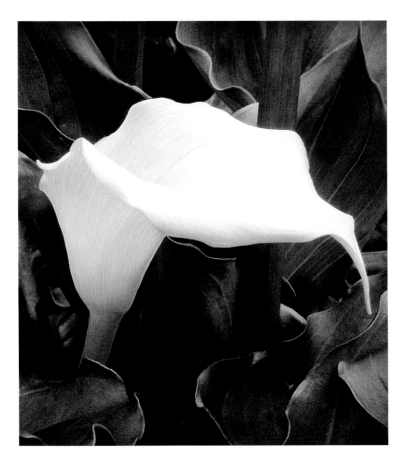

White bloom
Knowing the texture range of the digital camera, and also how to use the digital zone system described here to interpret subject brightness values, it is easy to achieve the desired image. In this image it was important to retain the subtle high values of the white petals while producing a dark background.

The zone system, devised by the American photographers Ansel Adams and Fred Archer in the 1940s, is an inspired visualization and exposure control method. It is a practical and easy-to-learn method of assessing the contrast of any scene or subject and, after interpreting that information, determining the optimum exposure required to produce the desired image. The system provides the photographer with a great tool for visualizing how a scene will look and achieving complete control over the technical aspects of exposure control. However, since much of the post-exposure techniques of the zone system – such as film development control – do not apply to digital cameras, some people may think the zone system has no place in the digital world. This is very narrow thinking.

For many photographers, the most important aspects of the zone system are the visualization (subject assessment before exposure) and exposure control it provides. Knowing how to assess the various brightness values of a subject with a light meter and how to interpret those values to produce the required image in the camera (with the optimum exposure) are crucial to controlling your photography. The zone system is the ideal tool for achieving this whether you are using a camera loaded with film or pixels (i.e. the CCD).

In film-based photography the zone system also provides practical techniques for realizing the visualized image through modified film development and the use of variable contrast printing papers. Since digital photography does not use film, the digital method of controlling subjects of high contrast is to use the multi-exposure technique described on the previous pages. This method allows you to record all the subject information you require, even for a subject with very extreme contrast, to permit your interpretation of that subject at a later time. For low-contrast subjects I recommend basing the camera exposure on placing the lightest tones where you want them. The lower tones will then contain maximum detail, which can later be darkened as necessary in your image editing program.

In film-based photography, many would agree that variable contrast printing paper is one of the best things about darkroom printing. Fortunately, we have a digital equivalent in the Levels and/or Curves commands in the editing software. You can think of these tone and colour adjustment tools as direct replacements for variable contrast paper and use them in the same way to control image contrast. The use of the above techniques makes the zone system as usable in the digital photography of today as it always has been in film-based photography – not bad for a system that is over 60 years old.

Misty trees

When the SBR is low, as in this misty scene, use the Curves adjustment control to simulate variable contrast printing paper. Here, I restricted the contrast change to the main tree using a layer mask on the Curves adjustment layer. Compare the final version below to the original (right).

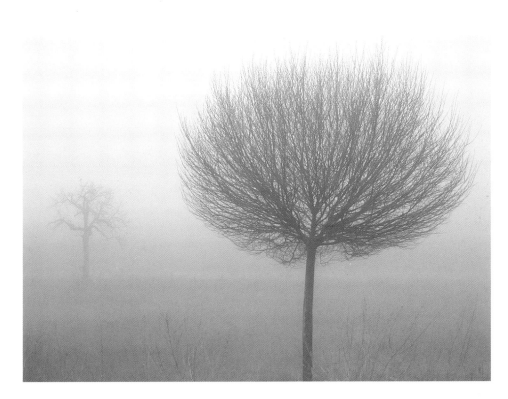

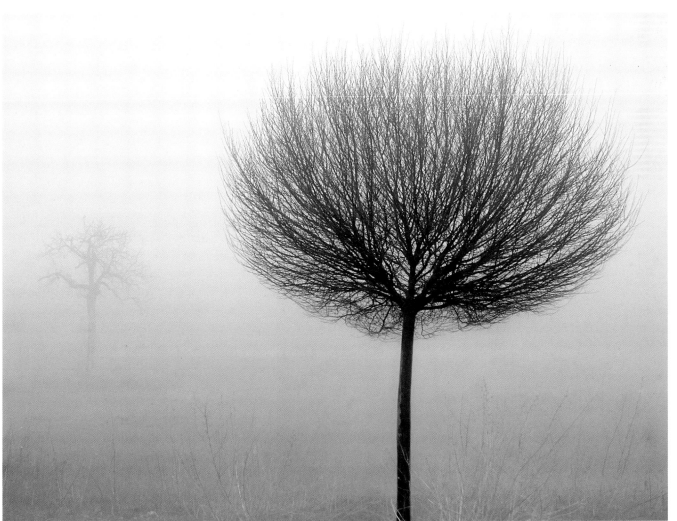

Visualization with the zone system

The zone system, as a visualization and exposure control method, is based on two important facts. First, all light meters, whether in the camera or a separate unit, produce a fixed tonal value no matter how light or dark the subject is in the scene. Second, since the brightness values of a scene are relative to each other, changing the exposure in the camera either lightens (more exposure) or darkens (less exposure) all the tonal values in the image by the same amount.

Everything you photograph is composed of a range of brightness values, known as the subject brightness range, or SBR, which in a black and white picture are reproduced as different tones of grey on a scale from black to white. However, a digital camera can record only a limited SBR in one exposure. Having calibrated your camera, as described on pages 40–1, you will know exactly the SBR that the camera is capable of recording with one exposure. Combining this knowledge with your assessment of the SBR of the subject to be photographed allows you to choose exactly the exposure (or two or more exposures if the SBR of the scene exceeds the texture range of the camera) that will record the information you need from the subject.

Zones

First exposure – the sky

I wanted detail in the shadows under the tanker to retain the interesting textures but I also wanted to retain the subtle clouds on the right of the sky. After measuring each area with the spot facility on my digital camera I determined that the SBR was nine zones (when the brightest cloud was placed on zone VIII the shadows were below zone O). Since the texture range of my camera is only seven zones I knew that two different exposures would be required. This is the first exposure, made by placing the lightest cloud between zones VII and VIII.

Zones

Second exposure – the tanker

This is the second exposure, made by placing the shadows (circled) on zone III to retain the necessary detail. The clouds have gone completely white, i.e. above zone X, and cannot be recovered from this exposure.

Pitch tanker

This is the final result of combining the two exposures using layers in Photoshop. Layer masks were used to eliminate the unwanted detail from the second exposure (see the screen grab). Local tonal adjustments and the channel mixer were then used to convert to black and white.

In the zone system, if you take a meter reading from an even-toned surface and use the exposure settings indicated, you have made a zone V exposure, which produces a zone V tone in the image. The meter always indicates a zone V exposure. If you increase the indicated exposure by one stop you will lighten everything in the scene by one zone and are making a zone VI exposure. Similarly, if you reduce the indicated exposure by two stops you are making a zone III exposure, which will darken everything in the scene by two zones. When you meter from an area of the subject and choose the level of exposure to use you are said to be *placing* that area on a specific zone. Thus, we say 'Make a zone IV exposure' or 'Place the area on zone IV'. All the other brightness values in the scene will then *fall* on a different zone relative to the placed zone. For example, if you place something on zone IV and there is another area that is two stops brighter (measured with the light meter), the lighter area will fall on zone VI, which is two zones higher on the zone scale.

Using this method, you can determine the SBR of a scene by choosing the lightest and darkest *important* areas of the subject in which you want to retain detail. Meter from each area and count the number of stops between the two meter readings. This is the SBR in terms of stops/zones. It should be clear from this that the SBR depends on which areas you choose to meter from. This will be determined by your own interpretation of the scene.

If the SBR is greater than the texture range of your camera it will be necessary to make two or more different exposures and combine them in your editing program to obtain all the required detail. Base the first exposure on recording the light areas correctly and the second on recording the dark areas. If the SBR is less than the texture range of the camera, meter the lightest area and adjust the exposure to place it on the desired zone (i.e. increase the exposure by the required number of stops/zones). This will make sure the shadow tones contain the maximum detail possible. Later, use either a Levels or Curves adjustment to darken the shadows as required. With this method, and a little practice, it is possible to visualize and control exactly how a scene will be recorded by the camera for later manipulation.

The zone system and image editing

Once you have captured a scene with a digital camera the next step is to use the editing software to realize your original, or even a new, visualization of the subject.

The zone system can be used to determine the appropriate exposure(s) for a scene by metering different parts of it and deciding where on the zone scale you want the various areas to be. Once the first metered area has been placed on a particular zone of the scale, the other parts of the scene then fall on other zones based on their difference in brightness relative to the original placement. Thus, if a shadow area with a meter reading of 1/60 sec at f/5.6 is placed on zone III to retain good detail, a lighter area with a reading of 1/60 sec at f/16 would automatically fall on zone VI, because it is three zones brighter than the shadow. (Remember that each change of zone represents one stop of exposure.) Thus you can produce the ideal exposure(s) to create the exact digital camera image you desire.

Once the image is loaded into the editing program, you can continue to think in terms of zones by using the eye-dropper tool and the Information palette to assess the various image tones. This is equivalent to using a densitometer to measure the density values of a negative before printing, to help determine the best approach. Ansel Adams often used this method to assess his negatives. The eye-dropper is your digital densitometer and can helpfully be used when using the channel mixer to convert colour images to mono or for checking the effect on the tones when using Curves or Levels adjustments.

Once the image tones have been assessed and any changes decided upon we use a Curves adjustment layer to make the necessary enhancements. Again, the eye-dropper tool can be used to determine where on the Curves chart particular tones fall before and after adjustment. Also, by clicking with the mouse on the chart we can create fixed points to isolate parts of the tonal scale. Care must be taken when fixing points since it is very easy to introduce unwanted tonal distortions, such as tone reversal.

As a reference, it is very useful to create your own personal zone scale, based on the

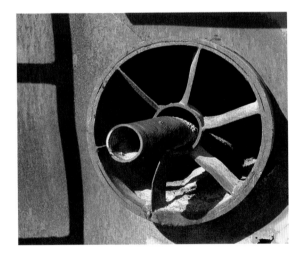

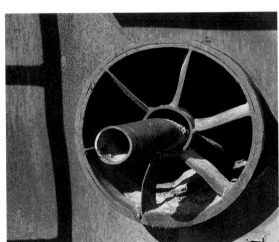

Using the eye-dropper tool

The eye-dropper tool displays pixel information in the Info palette as it is moved around an image. As shown here, this is very useful when converting a colour image to mono, as it enables you to obtain the tones you desire. Using the eye-dropper helps to prevent loss of detail in the subtle tones. The original colour image is shown for reference.

Adding a zone scale

You can add a personalized zone scale from your digital camera calibration on a new layer to act as a reference when using tone adjustment tools. Here I increased the canvas and copied the scale to a new layer above the original. A Curves adjustment layer was then added and the eye-dropper tool used to determine where on the graph different tones fell (circled in red).

Adjusting the tones and zones

By clicking on the Curves adjustment graph you can set points that can then be dragged with the mouse to adjust the final tonal values. The Curves screen grab shows how I have adjusted each half of the scale separately by placing a point in the middle of the chart. The Info palette screen grab shows the tonal values both before and after the adjustment. With the zone scale as reference you can make precise zone changes.

calibration exposures you made when determining the texture range of your camera, as described earlier (see pages 40–2). This personal zone scale can be opened and the eye-dropper used to check the tones in a new image against the known tonal values of your scale. In this way you can control any enhancements of the image quite precisely.

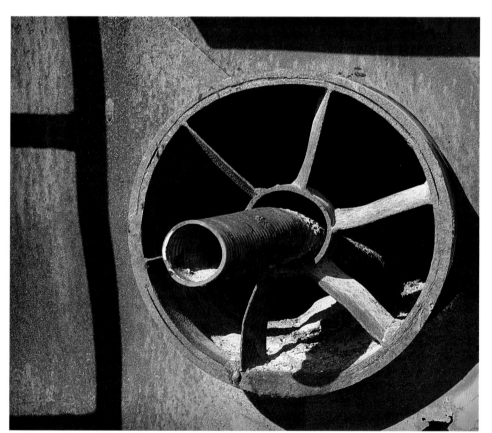

Pipe and ladder

The final image shows how I darkened the shadow values to give the shape of the circle more prominence and to define the shadow from the ladder. The colour was added using the Hue/Saturation method to simulate the rusty iron look. The edges of the image were also darkened to hold attention in the centre.

Film Scanning

For photographers who use medium or large format, and for those with a stock of 35 mm film images, it will be necessary to master the film scanning process in order to digitize negatives ready for digital editing and printing. Film may be scanned using either a dedicated film scanner or a flatbed scanner fitted with a transparency hood (basically a soft light source in place of the scanner's lid). Flatbed scanners provide more versatility than dedicated film scanners since they can also be used to scan other items, and are now capable of producing film scans of a high enough quality for serious users.

Preparing the film and scanner

It is worth spending a few minutes preparing both the film and the scanner, so that the image requires as little maintenance work as possible after scanning. The cleanliness of the negative and scanner are important in order to produce a clean scan. Remove any dust and marks from the negative and scanner to prevent them being scanned with the film (anti-static cloths and brushes are ideal for this). When using a flatbed scanner the glass platen easily picks up greasy fingermarks, so it is a good idea to use lint-free or surgical gloves when positioning the negative holders. Those with darkroom experience can equate this preparation to readying a negative and enlarger for printing; it saves a lot of unnecessary work later.

Once everything has been cleaned, use the clean film holders to load the negatives into the scanner and launch either your dedicated scanning software, such as SilverFast or Vuescan, or use the TWAIN driver supplied with your scanner from within your editing program (in many programs this is found under the File/Import menu).

Cropping

Once the scanning software's preview window has appeared (you usually need to press a preview button), the first step is to use the crop tool to define the area of the negative to be scanned. Doing this first means that the preview

image, file size information and any automatic correction settings will be using only the required image data. Allowing the crop to contain data from outside the desired image area will mislead the software into making inaccurate corrections. Also, any displayed histogram or levels graph will not be accurate as it will also be showing unnecessary image information.

Main control centre
In the following steps I will use the Epson TWAIN driver for scanning. This driver opens with all the main parameters available from the dialog shown here. The first step is to set the document and film type settings, which will initialize the scanner for the type of original you are scanning. The detail from the dialog shows the software is set to scan black and white film.

With some software it will be necessary to refresh the preview image (if this is not done automatically) so that it displays correctly after cropping. Also, you may want to use the zoom command so the preview is displaying only the cropped region of the image. This will make it easier to see any subsequent changes to the image.

1 The preview window (right)

Once the type of original has been specified you can produce a preview scan. The grab shows a set of 35 mm film strips in the preview window. The preview has been made based on all the tonal values present, which is why some of the images are dark and others are light. In this example two of the strips are Kodak Tri-X and the other two are Kodak HIE infra-red film. Since HIE has higher density values the Tri-X images are too dark.

2 Cropped preview

Having made a rough selection around the required image I then zoomed in to fill the preview window with that image. Note that the crop region contains unwanted areas and this has influenced the correction of the image, resulting in it being far too dark.

3 Redefined cropped preview

Adjusting the cropped area to contain only the desired image area has resulted in a much better preview. This is the image before any user corrections are applied.

Output size and scanning resolution

At this stage the image is cropped to shape and zoomed in to fill the preview window. The next step is to define the output dimensions, the output resolution and the bit depth of the scanned image. Each of these parameters affects the resulting file size and scanning resolution, and should be chosen carefully with the intended use of the image in mind.

For 35 mm originals many people recommend using the highest optical input resolution and bit depth of the scanner, arguing correctly that the resulting image can later be down-sized for different purposes. In my opinion serious scanner users should give more thought to their requirements. The maximum size/maximum quality ethos produces large file sizes, which can create storage and image manipulation problems later. There is little point in having unecessarily huge files. For example, many black and white photographers make prints no larger than A3 size, so they need final 16-bit files of only around 33.2 MB. Scanning a 35 mm black and white negative at 4870 dpi and 16 bits (the maximum optical quality on an Epson 4870 flatbed) produces a 60.6 MB file – larger than needed for A3 printing. Bear in mind also that many printer drivers will even reduce a 16-bit image to 8-bit before printing so it may be worth doing this when you have finished to save storage space and archive. If you are using larger formats it is very important to consider scanner settings.

Fortunately, most scanner software makes things easy, since the required input resolution is calculated automatically once the user has specified the desired output parameters of the print in the appropriate scanner dialog box fields.

If you do need to calculate the required scanning resolution manually for a particular negative and print size, a useful way is to work backwards from the print size. For example, an A3 print is 297 x 420 mm (11¾ x 16½ in), so a 35 mm negative of 24 x 36 mm needs to be enlarged 11.66 times (420 divided by 36) on the long side to fit. Multiplying the usual printing resolution of 300 dpi by this enlargement factor means you need to scan the original at around 3498 ppi (pixels per inch) to obtain a suitable file size.

Setting output dimensions

The next step is to specify the desired output size for the scan. This can be done in various ways; setting exact dimensions, specifying a zoom factor, or as here selecting from a predefined list of output sizes. This dialog shows the predefined sizes from the Epson software. I have also specified a resolution of 300 dpi which will be used with the output dimensions to calculate the scanning resolution.

Setting bit-depth

The final step is to specify the bit-depth for the scan. As shown here, for black and white

Bit depth

The bit depth of an image dictates the maximum range of colours or tones it can contain. Higher bit depths produce more image data in the file, which allows greater tonal manipulation without

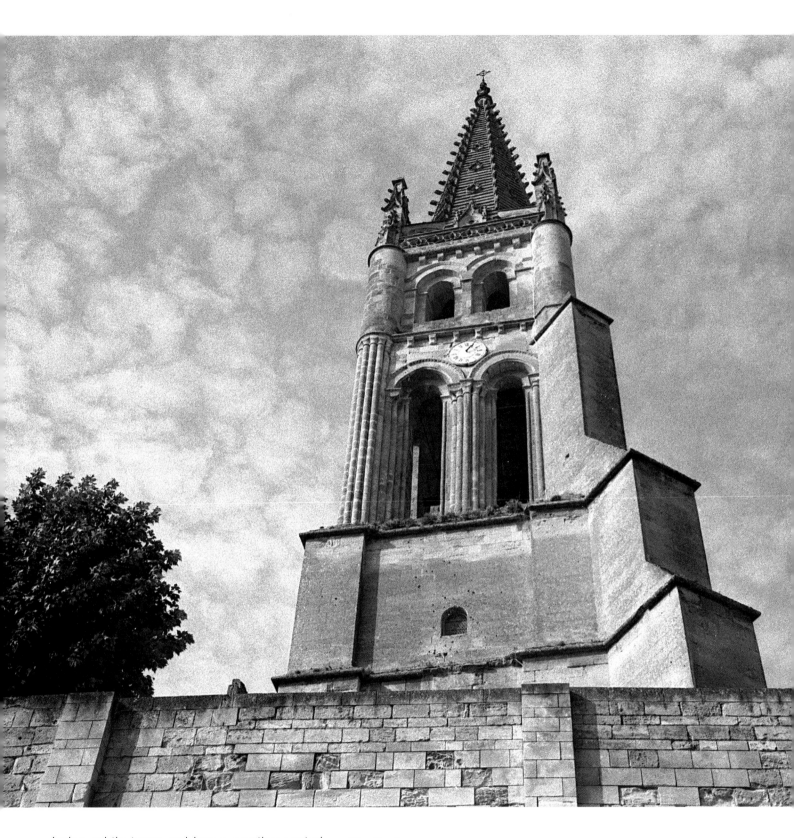

losing subtle tones and hence creating posteri-
zation effects. Therefore, for the smoothest
toned black and white images it is best to scan
at 16 bits (or 48 bits for coloured originals, i.e.
toned or pyro negatives).

The final scan
This is the scanned image produced using the automatic
correction applied by the scanning software. The result
is quite reasonable.

1 Assessing image with densitometer

If available, it is useful to assess the tonal values of the preview image with the built-in densitometer, as shown here. This will allow you to determine whether the image requires additional tonal correction to achieve the final scanned image you desire.

2 Adjustment using the histogram

The easiest way to make tonal adjustments is to use the histogram, as shown here. This allows you simply to move the triangular sliders to affect changes to the previewed image. Start by moving the black and white end points and adjust as needed with reference to the preview.

3 Tone curve correction

A more advanced and flexible method of tonal adjustment is to use a tone curve. This allows you to control different parts of the tonal range by changing the shape of the graph by dragging it with the mouse pointer. The extreme example shown here together with the preview shows one possibility.

Image corrections

Once all the scanning parameters have been set, closely examine the preview image displayed in the scanning dialog (refresh and zoom if necessary) to determine whether any contrast and tonal changes are required prior to scanning. It is wise to make some basic corrections at this stage, since the scanning software will be working with the raw image data and can thus produce a better scan that will be easier to work with later.

Start by adjusting the black and white points of the image. These represent the darkest and lightest possible tones in the scanned image (in zone system terms, zones 0 and X) and are modified either with a histogram or tone adjustment tool. Some scanning software has a densitometer or levels monitor to help achieve exactly the tonal value desired.

Once the black and white points are set the next task is to adjust the other tones of the image if desired. The best way to do this is with a curves tone adjustment tool. This allows you to manipulate a graph to change the dark, middle and light tones of the image. These are the tones between zone II and zone VIII of the zone system.

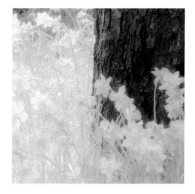

5 Image sharpening

The scanning software usually provides an image sharpening facility, as shown in this screen grab. Here I have chosen to apply a high amount of USM (unsharp masking) to the scan. The result is shown in the two image sections; one without USM and the other with USM. Normally, I prefer not to use USM at this stage.

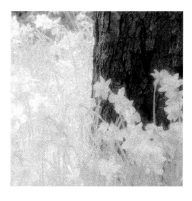

4 Using pre-defined adjustments

Most scanning software will provide pre-defined tone curve adjustments for some of the most common corrections needed. Here I have selected the Open Shadow correction, which has lightened the dark tones of the tree trunk, as shown on the accompanying preview screen grab.

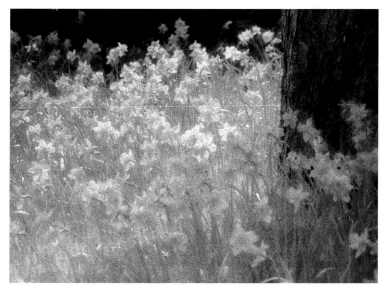

Infra-red daffodils

The final scan after making enhancements to the middle tone values in Photoshop. I also selectively sharpened the tree trunk using USM in Photohop.

Sharpening

Once you are happy with the tonal values of the preview image there are usually other controls that you can choose to use to make additional modifications to the image. The commonest of these is the Sharpen tool, which allows you to specify whether the scanned image will have some form of sharpening applied to it. The sharp-ening used is usually a form of USM (unsharp masking). Most programs only provide low, medium or high USM, which is not as flexible as the USM built in to most image editing software. It is a matter of personal choice whether to sharpen the scan or not. Personally, I prefer to sharpen my images just before printing and not when scanning.

Dust and grain reduction

As scanners have become more sophisticated the scanning software has kept pace with technology by providing the user with more features to reduce or eliminate some of the common problems encountered while scanning. Every scanner user, no matter how careful, must usually deal with those old enemies dust, scratches and film grain (as in traditional darkroom work).

Stone guardian

This is the final scan after some simple modification in Photoshop. The image has been toned and has also had the Diffuse glow filter applied in Photoshop.

Dust and scratches leave unwanted marks on your scanned images and these will need to be cleaned up before serious work can begin. Dust and scratch removal is now incorporated into

Dust and grain reduction

These three enlarged sections show the result of applying dust removal and grain reduction in the scanning software. The first image has had no correction, the second a medium amount of correction and the third a high amount. The accompanying dialog screen grab shows the settings.

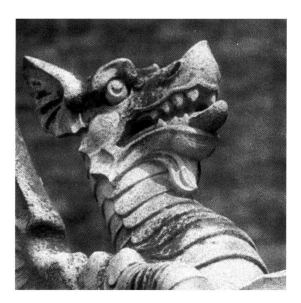

modern scanning software, which helps to eliminate, or at least reduce, the artefacts produced in the images by dust when scanning film negatives.

Dust and scratch removal is done by softening the image in areas where sharp contrast occurs to 'fill in' the spots left by the dust. This method must be used with care to avoid unnecessarily softening the image and losing subtle details and tonal values.

Digital ICE®

Digital ICE® is a hardware system of dust and scratch removal that utilizes special infra-red detection. Unfortunately, this system is usable (at least on Epson scanners) only with chromogenic or colour film originals. The system does not work with traditional silver-based negatives: just to be awkward I tried it and it mangled all the details of the subject. Digital ICE® is capable of higher-quality correction than the software-based dust and scratch removal. The downside is that it takes a much longer time to scan the image.

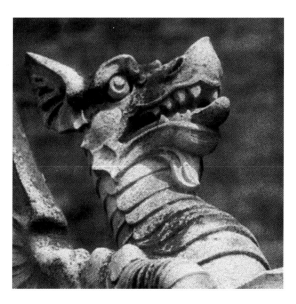

Every dust removal system will soften the image, and it is a matter of personal choice as to how much loss of sharpness you are prepared to accept. Be aware that it may not be possible to fully recover the lost sharpness later. Personally, I prefer to retain image sharpness and use only a slight amount of correction as necessary, preferring to use the Clone or Healing brush in Photoshop.

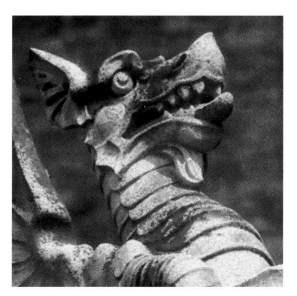

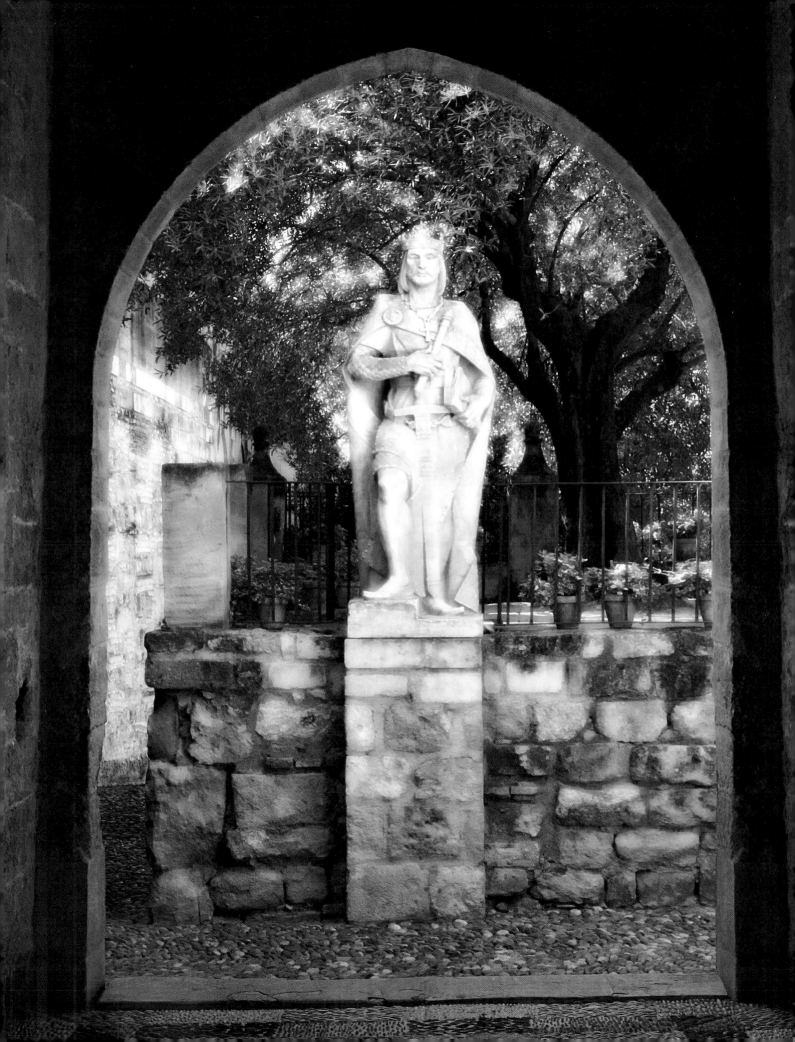

Chapter 3
Enhancing images

In Chapter 2 we looked at the various techniques of obtaining an original digital file. In this chapter we explore a variety of creative techniques for enhancing the image and creating some special effects.

We start by examining the best method to use for converting a colour image to a monochrome one. This is an important technique for everyone, but especially for the many people who may have a collection of colour pictures from which they want to make monochrome prints, or who have previously produced colour digital files with their digital cameras.

Once we have a monochrome image, we explore some interesting techniques for improving and/or altering the picture. These follow many of the tried and trusted techniques of the traditional darkroom. You will soon see how easy it is to reproduce digitally what were once very complicated and less than predictable procedures. Most advanced darkroom procedures require a great deal of knowledge and skill from the photographer, but even with the necessary skills many of the methods remain unpredictable. Using digital image software it is very easy to simulate traditional darkroom effects in a predictable and repeatable way, making it possible to produce stunning results. Of course, you will need to acquire the necessary digital skills to make this possible!

Shining knight in arch
Digital imaging has provided the necessary tools for creative freedom; but this is not enough. Having a keen eye for, and an understanding of, light and how it interacts with the world around us is vital if you are to capture unusual moments. In this picture, the strong sunlight behind the statue was bouncing off a light wall, making the knight literally glow. Thinking of the shining knights of Arthurian legend, I applied some enhancement in Photoshop.

Colour to mono conversion

If you are using a digital camera, or scanning colour originals, I strongly recommend that you produce full colour RGB digital files. Although this book is about digital black and white, and it would seem logical to use your digital camera in the BW mode when making pictures, starting with a full colour original provides greater flexibility once the digital file is opened in your editing program. Starting with a colour image file allows the colour data to be manipulated during the conversion from colour to monochrome.

Channel mixer

Although there are various ways to change a colour image into monochrome – you can convert to greyscale mode, reduce colour saturation to nil,

or simple copy one of the individual colour channels to a new file – by far the most flexible method is to use the channel mixer. This allows you to create a monochrome image by mixing together different proportions of the data from the individual colour channels (which actually contain only greyscale values). This provides a powerful tool for actually controlling the tonal values of the final monochrome image. It is the digital equivalent of using traditional contrast control filters (i.e. red, green, yellow and orange filters) at the camera stage with black and white film to alter the tonal relationship of subject colours. The use of the channel mixer is far more powerful and flexible than using traditional contrast filters because it allows almost infinite adjustment of the tonal values.

If your editing program has the facility, it is best to use the channel mixer as an adjustment layer. The channel mixer in Photoshop uses percentage values and it is recommended that the total of the three channel percentages is 100 per cent. This is to avoid undue loss of individual tonal values, which can cause loss of smooth gradation or posterization in the print. You can use the Histogram palette to watch a graphic display of the tonal values as you work in the

Colour original

One of the best aspects of digital imaging is the ease with which photographers can now convert a colour picture into black and white. I decided to convert this colour original into monochrome using the channel mixer in Photoshop.

 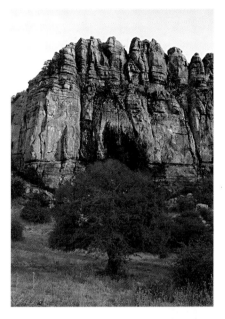

Colour channels (above)

These three images show the tonal distribution of each of the colour channels, Red, Green and Blue, of the original image. Before using the Channel Mixer command determine which colour channel is nearest to the result you desire. When you open the Channel Mixer dialog, start by selecting the required colour channel from the drop-down list.

El Turcal – Andalusia (right)

This is the converted image. The values used in the Channel Mixer dialog are shown in the accompanying screen grab (opposite). These values are a matter of personal taste, so don't be afraid to experiment.

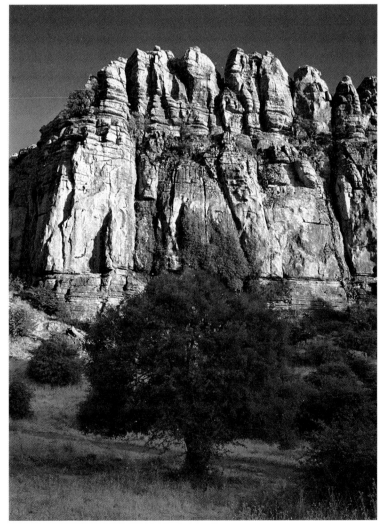

channel mixer dialog box. This will clearly show if any undesirable loss of tonal values is occurring.

Before opening the Channel Mixer dialog, examine the individual colour channels of the image to determine which has tonal values closest to what you desire. When you open the channel mixer, start by using the Output Channel drop-down list to select the required colour channel. Next, check the Monochrome box to display only black and white tones and experiment with the Red, Green and Blue sliders to change the tonal relationships in the image. Click OK when you are happy with the result.

Enhancing images

Basic corrections

Whether you have scanned film or have used a digital camera to originate the digital image, it is likely to require some basic tonal correction. Although prior to scanning film you can make tonal adjustments in the scanning software, it may also be necessary to fine-tune those adjustments using your editing program. Digital camera images, even at the optimum exposure for your desired result, may be improved with basic tonal enhancement. There will be many times when the exposure was not quite optimum or, more commonly, the subject brightness range was not as desired, in which case you will need to make tonal adjustments.

There are different ways of adjusting tonal values but the two main tools used in Photoshop are the Levels and Curves commands. These, like most of the adjustment commands, are best used as adjustment layers since the original image data is unaffected when adjustment layers are utilized. Making a data-changing manipulation on the original image is not recommended unless

Black & White Digital Photography

Adjusting contrast

I wanted to give this relatively low-key detail a little more contrast. The easiest way to do this is to use the Levels command.

Levels dialog – original

This screen grab shows the dialog box of the Levels command, displaying a histogram of the tonal values of the image. Note that the tone range does not occupy the whole chart. For example, there are no black or white tones in the image.

Levels dialog – corrected

To increase the overall contrast of the image I moved the black and white triangular sliders (circled in red) until they touched the ends of the histogram. Note that this does not unduly affect the middle tones of the image.

Coat of arms

This is the corrected image showing the result of the increased contrast, which has accentuated the textural lighting on the subject.

absolutely necessary (I can't think when this might be the case). Try to avoid using the Brightness/Contrast command since this isn't flexible enough for optimum control.

Black and white end points

The first step is to use the histogram to evaluate the image in terms of overall contrast. Then, add either a Levels or Curves adjustment layer above the image layer and adjust the black and white end points until the desired contrast is achieved. In the Levels dialog, move the black or white triangular sliders to adjust the black and white end points. With the Curves dialog open, use the mouse to drag the ends of the graph line. Be careful not to inadvertently lose essential details in the darkest shadows or palest high values by over-correction. If the sliders are moved into the data graph, anything outside of them will be either black or white.

Mid-tones

Once the desired overall contrast has been set using the black and white points, the intermediate tonal values (known as the gamma) can be adjusted if necessary. The grey slider below the graph in the Levels dialog adjusts the intermediate values. Moving the slider left lightens the tones and moving it right darkens them. In the Curves dialog, clicking and dragging on the graph line with the mouse allows you to change the shape of the curve, altering the tonal values accordingly. You can set fixed points on the curve by clicking with the mouse to allow very fine control of portions of the tone range. The Curves command gives you the most flexibility but requires more care in use. It is very easy unwittingly to introduce unwanted solarization into the image using the Curves graph.

When the overall contrast and gamma have been adjusted, save the file as a master copy before further enhancements.

Town square – Archidona, Spain

The final, toned image shows how the buildings have been brought to life and the outlined figure made more prominent.

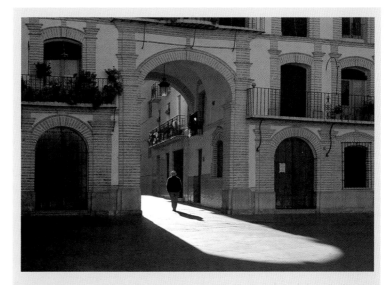

Adjusting middle tones

For this image, the subject contrast was quite high and I exposed for the lightest values. There wasn't time to take a second image (see pages 60–61) so it was necessary to correct the original using the Curves command.

Using the Curves dialog

The Curves command dialog displays a graph, which you can click on with the mouse to create control points. Using the control points allows you to shape the graph to adjust the tonal values of the image. This shot shows how I have lightened the darker tones of the image quite significantly.

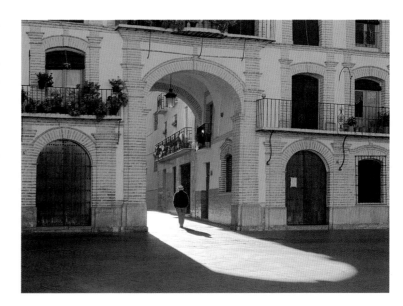

Correcting chromatic aberration

Even the best quality lenses can suffer from the problem of chromatic aberration. Longitudinal chromatic aberration is created when one of the three primary colours does not focus at exactly the same plane as the other two. This results in a coloured fringe along the edges of details of an image. To check for this problem easily zoom the image window to about 300 per cent.

Automatic correction

Digital camera images saved in the RAW format can have chromatic aberration corrected using the RAW file converter in Photoshop CS. The Photoshop RAW converter has specific controls to eliminate two different chromatic aberration colours. For other file types (TIFF or JPEG) the Picture Window 3 editing program has a specific filter (filters are called transformations in this program) that is designed to remove chromatic aberration defects.

Manual correction

With editing software that doesn't provide automatic chromatic aberration correction you can reduce the problem manually using the colour channels. In earlier versions of Photoshop and when using other software, make the relevant colour channel the active channel (e.g. in Photoshop click on it in the Channels palette). Also make the RGB channel active so that you

Original image (above)
This close-up section of the colour original shows that chromatic aberration has produced a marked colour fringe on the left edge of the statue.

Original in greyscale (above)
This greyscale version of the colour original shows how the chromatic aberration has left a light edge around the statue.

RAW conversion correction (left)
If the colour original is in the RAW format, the Photoshop RAW converter can be used to remove the colour fringe. This screen shot shows I have adjusted both the Red/Cyan and the Blue/Yellow values to correct the problem.

Corrected images
These two images show the result of removing the chromatic aberration in both the colour original and the greyscale version.

can see the full colour image. Now slightly move the offending colour channel to align it more accurately with the correct colour channels. This will reduce or remove the colour fringe. It may be necessary to move more than one channel if the fault is a combination of two colours.

One way to move the channel image in Photoshop is to use the Offset filter (Filter/Other menu). In the Offset dialog set the direction boxes to either plus or minus 2 pixels and watch the preview. This movement may be too much but more adjustment is possible. Apply the filter then immediately go to the Edit/Fade Offset command (you must do this straight after applying the filter or the option is lost). In the Fade dialog reduce the effect as needed using the Opacity slider and click OK. Once the chromatic aberration has been reduced the image will be slightly less sharp but this can be fixed later.

Manually correcting chromatic aberration

For images that are not in the RAW format, or if your image program doesn't have a specific chromatic aberration command, it is possible to reduce the problem manually. First decide on the dominant colour of the fringe then make that colour channel the active channel. Use the Move tool (or the Offset filter in Photoshop) to move the colour channel one or two pixels until the fringe is removed. Here I used the Offset filter on the Green channel to move it two pixels. This was actually too much so I used the Edit/Fade command immediately to reduce the movement by 25 to 75 per cent or 1.5 pixels (making this small reduction is not possible in any other way). The corrected image is not quite as good as the RAW format corrected version.

Corrected image

Channels palette

Offset filter dialog

Edit/Fade dialog

Using the clone tool

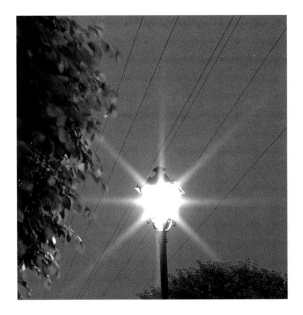

The unwanted detail

This section of a night shot shows the proverbial photographer's nightmare, overhead cables. In the digital world such unwanted subject matter can be quickly removed using the Clone tool.

It is very rare to have a new digital image that doesn't contain at least some artefacts or other unwanted details that need to be removed before more serious enhancements can be made. Artefacts are blemishes in the image, such as dust or scratches, that offend the eye (as on an unspotted darkroom print) and simply should not be present. Such artefacts spoil the appearance of a picture and must be removed.

Most image editing programs provide a special painting tool called a cloning brush (in Photoshop it is the clone stamp tool), which is used to paint one part of a picture over another part. The source image for the clone tool can be either a section of the same image or it may be cloned from an entirely different image. Cloning from the same image is normally used to remove blemishes or repair/replace recognizable details, whereas cloning from a different image is normally used when combining images into a montage.

Selecting the tool and tool options

The clone stamp tool (sometimes called the rubber stamp tool) is selected from the tools palette. Since the clone tool is simply a specialized brush there are brush options available such as the size of the brush, the blending mode to use and the opacity (or strength) of the brush.

Selecting the brush origin (left)

Before you can use the clone tool it is necessary to define (Alt/Click or Option/Click) where you want the tool to clone from. For simply cleaning up an image the clone origin should be chosen from close to the offending detail. As this section shows, the cross defines where the tool origin is and the rubber stamp icon where the tool will cover detail (the cable lines).

Finished result (right)

This Is the final image after removing the cables. One area of difficulty in this example was where the flare from the light changed the tonal value of the cables. For these areas I found the healing tool in Photoshop easier to use as it automatically adjusts for changes of tone. Like most editing tools, the healing brush is not perfect and must be used with care, particularly when choosing the brush's origin point.

Removing faults

To remove unwanted detail from a picture, such as overhead cables or dust marks, requires a little thought before starting. It is easy to make the correction obvious if you do not observe a few simple precautions. For example, the most obvious part of a picture in which to see blemishes is in areas of uniform tone such as skies. To correct faults in areas of similar tone you need to use the clone tool to pick up a part of the image that matches the tone and detail of the blemish. For example, when correcting a fault in a sky tone make sure the clone tool copies from an area of the same tone and contrast (normally this would be very close to the actual fault).

Areas of a picture that contain random detail, such as foliage, need careful handling when using the clone tool. If the clone source is not randomly selected you will be left with obviously duplicated parts of the image.

Adobe Photoshop has a more advanced version of the clone tool for removing blemishes, known as the healing brush. This tool tries to match the tone, colour and contrast of the area being corrected automatically, making it easier to use than the normal clone tool. I find this tool is great to use in areas of uneven tone such as cloudy skies.

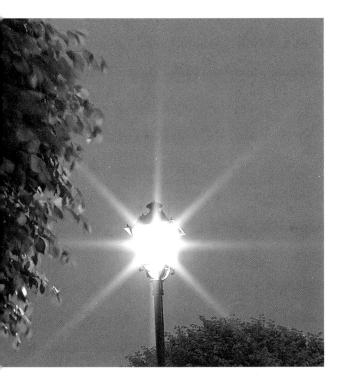

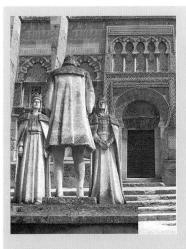

Close-up of cloned area (above)
Here we see the job of cloning the wall areas over the unwanted column. It is important to clone different but related areas to make the result convincing.

Cloning details (above)
This composite image shows one of the uses of the clone tool for recreating subject detail. The background is the same image duplicated and moved to make sure the door is visible. This results in the left edge of the image being behind the statues. This needed to be replaced by details from other parts of the walls.

Final composite image (right)
The final result shows how part of the window was also cloned. Once the cloning was done I used the brush tool in overlay mode with low opacity to blend the tonal values. The background was later softened slightly to give the impression of differential focus to make the statues more prominent.

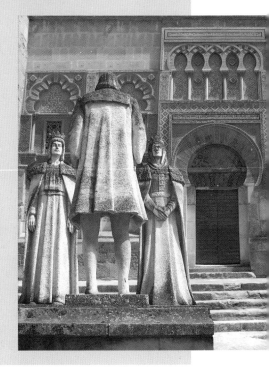

Cloning picture details

The most difficult task with the clone tool is to replicate easily identifiable details or objects from one part of an image to another. For example, you may need to clone some important detail of the image to make the picture look better or to add detail around the edges of the image after rotating the canvas. This type of cloning requires great care and a good eye to make sure the cloning is seamless and undetectable. However, once mastered, the clone tool provides a great deal of creative licence.

Selective burning and dodging

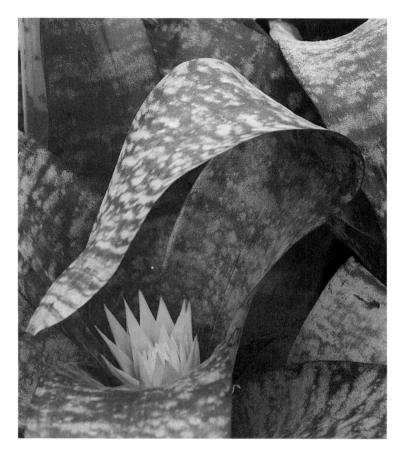

Creating a dodge and burn layer

The first step is to create a new layer filled with 50% grey and set to Overlay blending mode. The New layer dialog shown here shows how this can be done in one go. The layers palette screen shot shows the new layer above the original image ready for editing.

Original image

This picture of a flowering plant was taken in a garden centre under less than ideal lighting. To improve the tonal distribution and visual appeal of the image I decided to use selective dodging and burning; just like I would if making a traditional darkroom print.

Once the overall contrast and intermediate tonal range of the image is as desired, it is time to consider any local enhancements that you may require to fulfil your visualisation of the subject. The traditional darkroom terminology for local lightening and darkening of tonal values in a print is dodging and burning and most image editing programs use commands with these names for the same tasks.

The Dodge and Burn tools in Photoshop are specialised brushes and you use the brushes palette to select the brush size. These tools also have options to fine-tune their effect. You can choose the tonal range the tool will affect most i.e. Shadows, Midtones, or Highlights and the

Exposure value. The exposure value option is similar to the opacity setting of the other paint style tools; it modifies the strength of the tool. To use the Dodge or Burn tools simply paint on the areas you wish to lighten or darken (it is advisable to use a copy of the image layer until you are happy with the result).

To restrict the dodging and burning to specific parts of the image make a selection first using any of the selection tools. Feathering the selection will help to blend the modification into the surrounding tones.

Using an Overlay Grey Layer

A very elegant and practical method of dodging and burning is to create a new layer above the image and fill it with mid-grey (value 128). Change the blend mode to Overlay. The Photoshop New/Layer command dialog allows all this to be done in one dialog box. With an Overlay blend mode, the middle grey layer will appear invisible but when you paint onto it using

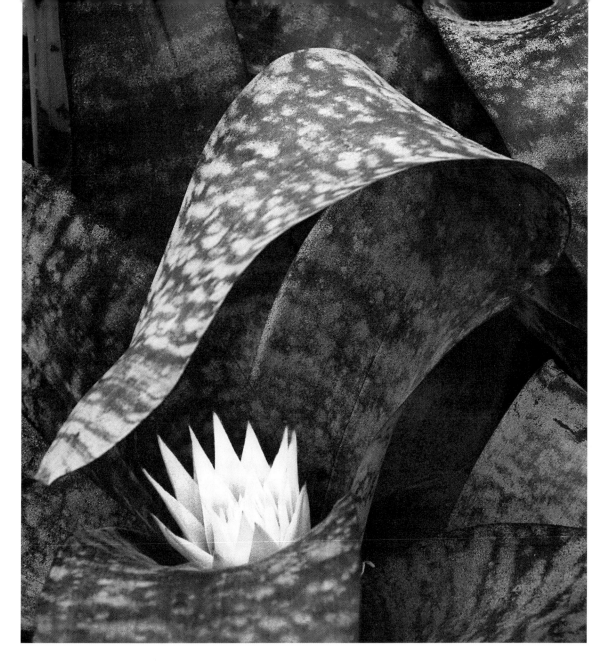

Corrected flower image

The final image shows the results of the dodging and burning layer. The actual dodging and burning can be seen more clearly on the accompanying image of the dodging and burning layer and the Layers palette screen shot.

either a black or white brush with a low opacity setting the tones of the actual image will darken or lighten as if you had used the Dodge or burn tools. You can do all your local dodging and burning on this one layer. Any mistakes can be corrected by painting over them with 100% middle grey (value 128).

Posterization

Posterization (or tone separation) is the name given to the process of simplifying a black and white image into only a few key tones. Traditionally, these would have been black, middle grey and white. The traditional posterization method required various line or lith film negatives to be made and then sandwiched for final printing.

Digital posterization is both very simple and much more controllable. In Photoshop, simply add a Posterize adjustment layer above the main image and specify the number of tones required. Specifying two tones produces a simple black and white image similar to a straightforward high-contrast line film effect. The best effect is

achieved using three or four tones. Colour can be applied to the posterized image using a filled layer above the image with the blending mode set to Overlay.

Picture Window Pro provides a more advanced form of posterize filter than Photoshop using the Posterize special effect transformation. The dialog box for this transformation offers several options for controlling the effect. Not only can you specify how many tones to retain but also, using the colour picker, exactly which tonal values the final tones will have and whether or not to apply colour to them. This is a great way to produce pop-art-style posters.

Black and white only

This version uses only two tones, resulting in the complete elimination of all grey values. This is similar to the simple darkroom line negative effect. The screen grab shows the Photoshop Posterize command dialog box.

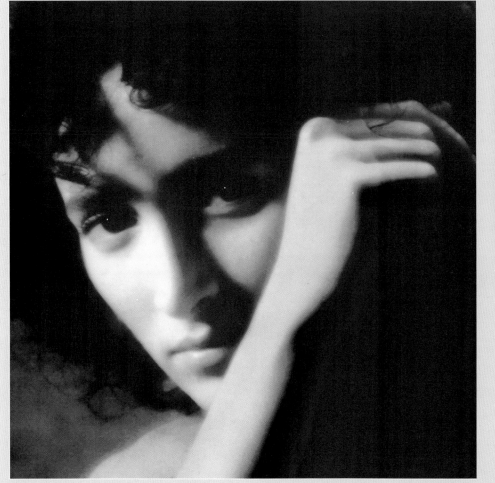

Female portrait

This image is suitable for the posterization technique because of its bold lighting and strong composition.

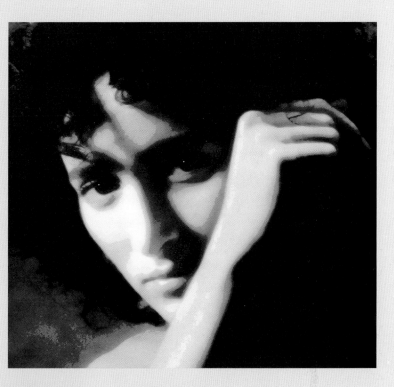

Four-tone image

In this example I have reduced the image to four tones of grey. This has retained more of the structure of the subject.

Finished portrait (above)

The final version is more complex in that I copied the original image on to a new layer and applied the four-tone posterization to the new layer. I then changed the blend mode of the poster layer to Soft Light so the two layers combined to produce this more subtle image. The Layers screen grab shows the final arrangement.

Picture Window Pro variation

This example was created in Picture Window Pro, which allows the actual tonal values you want in the image to be selected. This is shown in the screen grab of the Posterize transformation dialog box.

Bas-relief

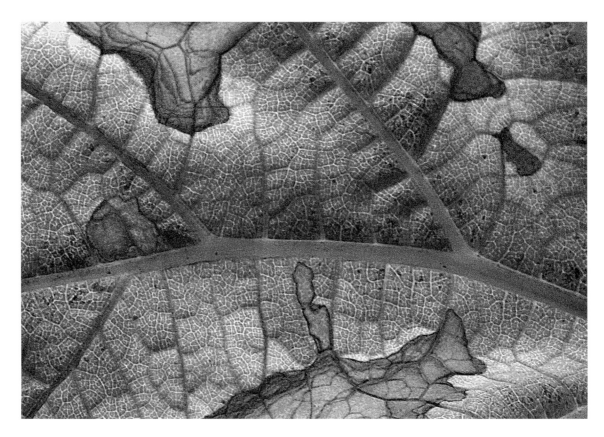

Bas-relief is a traditional method of creating a three-dimensional effect in a photograph. To achieve this effect in a darkroom requires the making of a high-contrast copy of the original on line or lith film. This copy is then placed in contact with the original, slightly out of register, and the combination is printed.

Bas-relief can be simulated easily in an image editing program such as Photoshop by using the Bas Relief filter (the Emboss filter can produce similar results). True embossing is the process of raising an image or text above the original flat surface of the paper; it is often used on expensive stationery and as an artist's stamp or logo on fine art prints. The Bas Relief filter simulates this effect by creating highlights and dark shadows along the edges of the image details.

The final result is controlled by Smoothness, Detail and Light settings in the filter dialog, the Emboss filter uses Angle of light, Height and Amount settings. Start by making a copy of the main image layer and apply the filter to this new layer. Experiment with the Blending mode of the

Leaf close-up
This image of a leaf is suitable for the bas-relief effect because it has good detail. The first step is to copy the main image to a new layer to preserve the original.

filtered layer to achieve the effect you want. The Overlay, Hard light and Linear blend modes work well, depending on the image.

For a different and more subtle bas-relief effect, make a copy of the image layer and use the Levels command to increase the contrast of this layer dramatically (this simulates using lith film). Next, copy this layer and invert the tones (in Photoshop use Image/Adjustments/Invert). This produces a high-contrast positive and negative. Move the high-contrast positive layer one pixel down and one pixel left (for ease use the Offset filter). Next, move the inverted negative layer in the opposite direction (reverse the values in the Offset filter dialog). Finally, change the blending mode of both layers to Soft Light. Experiment with the blending mode of each layer for alternative results.

Using the bas-relief filter

In this version I used the Photoshop Bas Relief filter with the following settings: Detail 4, Smoothness 6, and Light top. These settings have produced quite a dramatic effect. The filtered layer was set to Overlay blending mode (see the Layers screen grab).

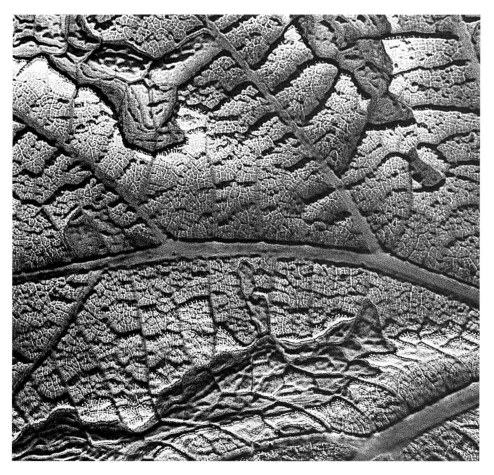

Using high-contrast copies

This final variation was made using the high-contrast layers method described opposite. The colour was added using the Hue/Saturation method. The Layers screen grab shows the final arrangement.

Solarization

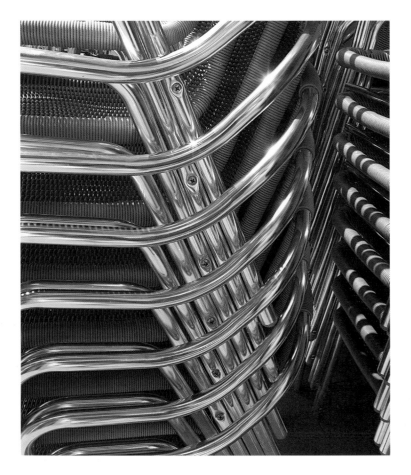

Stacked chairs (left)
This image of a stack of chrome-legged chairs is ideal for the solarization technique, because the chrome is producing lots of highlights and other reflections. This is the original image.

Solarization 1
This is the result of using a Curves adjustment layer to create a solarized effect. Note how the highlights of the original are now black and the deeper shadows have become lighter. The screen shot of the Curves dialog shows that the shadow tones have been lightened quite a lot.

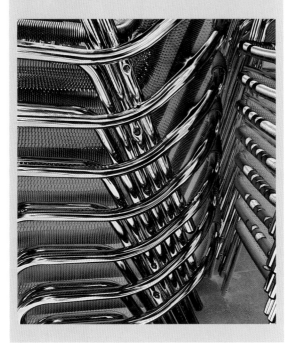

In traditional photography true solarization occurs when a bright part of the subject is given an exposure that takes it over the shoulder of the characteristic curve of the film. By an amazing quirk of physics, this level of exposure causes the affected area actually to lose density in the negative and ultimately reverse its tonal value. A classic example of true solarization is seen in an early Ansel Adams landscape picture, which shows an almost black sun in the sky.

Digital solarization is achieved by inverting the tonal values of the image. In Photoshop, the quickest way to solarize an image is to use the Solarize filter (Filter/Stylize/Solarize) but this doesn't allow any user control. For complete control of the effect, use a Curves adjustment layer to invert the tones of the image in unusual ways. In the Curves dialog click on the white point and move it right down to reverse the highlight tones. Similarly, move the black point

upwards to reverse the shadow tones. Then, click and move points on the line of the graph to change the tonal values of the other tones. By changing the shape of the curve you can achieve some unusual tonal variations.

If you want to add coloured tones to the image when creating the solarisation effect (to create a multi-toned look), first convert the image to RGB mode and then use the Curves dialog to change the individual red, green or blue colour channels. The solarization effect is achieved using the combined RGB channel.

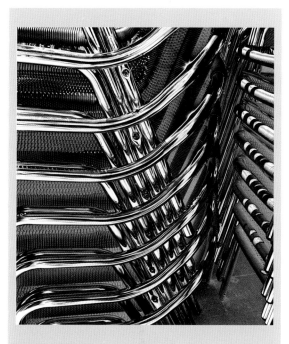

Solarization 2

As this image shows, changing the shape of the curve in the Curves adjustment layer creates totally different results. Compare the screen shot of the Curves dialog with the previous version and note how the darker tones have been lowered in value to increase the contrast.

Multi-toned solarization

This version of the image shows how unusual multi-toned effects can be achieved, after converting the image to RGB mode, simply by adjusting the individual colour channels in the Curves dialog. Here I have given the chrome a steely blue colour and the rest of the subject a warm brown contrasting colour. Although this result is almost like a colour photograph, it gives you a good idea of what can be achieved.

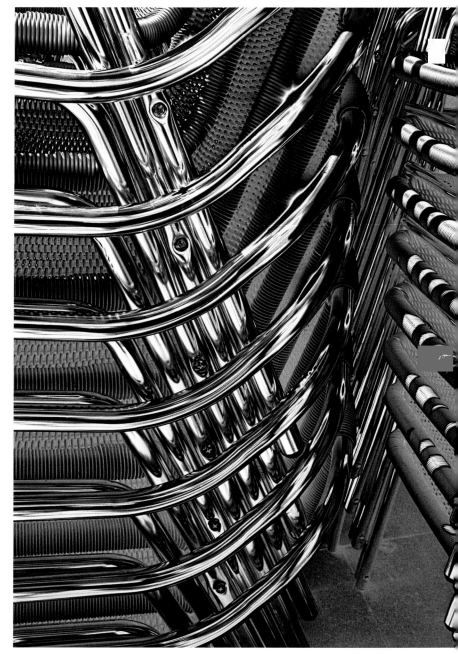

Lith prints

Traditional lith prints are a combination of subtle, creamy, smooth light tones and gritty, punchy dark tones. Lith prints can also exhibit subtle or dramatic image colours, which are often further enhanced by chemical toning, giving them a unique visual quality.

Lith printing is a difficult process to master even for experienced print makers, due to the unpredictable nature of infectious development and the variance of print materials. It is therefore difficult to produce repeatable results. Fortunately, with very little effort it is possible to simulate the qualities of a lith print digitally.

To simulate a lith print you need to produce smooth light tones and deep, grainy shadows. Since lith printing usually produces a colour change in the print it may be necessary to emulate this colour effect. Generally, if the colours of a lith print are kept subtle the print exhibits an almost ethereal quality of light.

As with most digital techniques, there is more than one way to achieve the look of a lith print, but I always prefer methods that allow me the fullest control at each stage. The method described here is slightly different to the one I used in my earlier book *Digital Image Making,* but it provides greater control.

Creating the image

If you are starting with a colour image convert it to monochrome using one of the methods described earlier (see pages 74–5). Make any tonal adjustments or other visual enhancements you desire to obtain your final image (these can be done in Grayscale mode to keep the file size manageable). When the image is ready convert it to RGB mode to permit the use of colour layers.

Creating new layers

Copy the background image layer on to two new layers. Name the top layer 'Darks' and the middle layer 'Lights' (or whatever you wish). Make sure the 'Darks' layer is above the 'Lights' layer. Change the blend mode of the 'Darks' layer to Overlay mode.

Adding colour

For flexibility, use a separate Hue/Saturation adjustment layer with the Colorize option checked to add colour to each of the new layers. Experiment to obtain colours you like. Since the 'Darks' layer is in Overlay blend mode it will interact with the colour of the 'Lights' layer. Once you are happy with the colour, merge the 'Darks' layer with its adjustment layer (you can link the

1 Mono image in RGB mode
The original image, after basic tonal adjustments, is converted to RGB mode.

2 Hue/Saturation layers
Be fairly bold with your colours when applying the Hue/Saturation layers. The final colour will be a blend of these colours.

3 Film grain layer
This shows how the layer mask applied to the 'Grain' layer has restricted the noise filter to the shadow areas of the image.

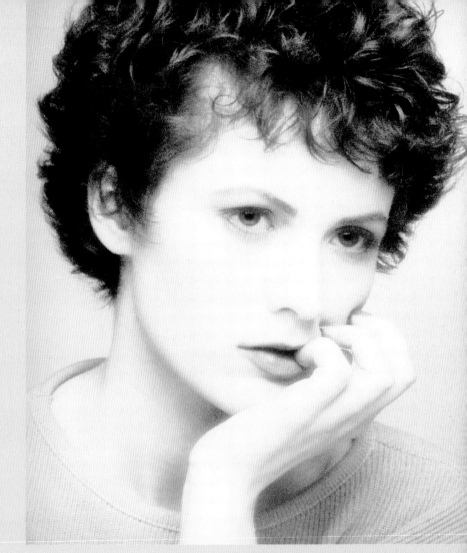

4 Final layers
This screenshot shows the final arrangement of the Layers palette (the original layer at the bottom could have been deleted).

Pensive girl
After applying the final Levels layer, the image simulates the visual qualities of a traditional lith print.

two layers and use the Merge Linked command). Do the same for the 'Lights' layer. Once the layers are ready you can adjust the opacity of the 'Darks' layer to modify the final colours.

Adding grain
To simulate the grainy look for the dark tones, create a new layer above the 'Darks' layer and fill with 50 per cent grey. Set this layer to 'Soft Light' blending mode. Use a Noise or Grain filter to add gritty grain to this layer. Name the layer 'Grain'. In this portrait example, I knew that the image would need to be sharpened later so to avoid the grain looking too sharp in the final image I used a very small amount of Gaussian blur (0.4) on the 'Grain' layer to take the edge off the effect.

Restricting the grain effect
Since the grain needs to appear only in the darker tones a layer mask is needed based on a selection of the shadow tones. With the

Colour Range command, use the eyedropper to sample the dark tones you want to use in the selection (or use the Shadows option from the drop-down list). With this selection active, use the Add Layer Mask command to create a layer mask for the 'Grain layer'. You should see grain only in the darker tones of the image. If the grain is in the light tones invert the image in the layer mask.

Creating smooth light tones
The final step is to add a Levels adjustment layer at the top of the layer stack. Move the middle slider to the left to lighten all the mid-tones of the image. For finer control you may wish to use a Curves adjustment layer. This final step will produce those lovely creamy, smooth light tones that give lith prints much of their beauty. As a final touch, experiment by making subtle adjustments to the tones and colour of the different layers to obtain exactly the mood you want.

Texture effects

A popular style that seems to prevail in black and white photography is the creation of prints with pronounced grain. It seems to be true that photographers fall into two groups: those who love grain and those who hate it. Since digital cameras produce inherently less grain effect than traditional film it is necessary to consider film grain as a special effect which must be applied to an image in the editing software. Most software provides filters for just this effect.

Another popular technique in darkroom printing is the addition of simulated texture to a print. Traditionally, this is done using a low-contrast, underexposed negative of some real texture, which is printed with the image negative. As with film grain, editing programs usually have a filter that can be used to create texture on the image.

Film grain

In film-based photography, film grain is an inherent part of the negative (usually produced using very fast film) and cannot be separated from it. With digital imaging the grain is added to the original image, so it is possible to produce grainy effects on any image. Since you can save the grainy version of the image separately you can now have the best of both worlds.

Although it is very easy to add a grain effect to an image it is very difficult to simulate the actual grain structure of real film. However, with a little imagination and the use of the editing tools, you can alter the appearance of the grain effect to give the image different 'looks'. The examples shown here demonstrate some of the possibilities.

Creating film grain

I wanted to create film grain that more closely resembled the tight, twisting grain of traditional Kodak Tri-X film that has been severely push-processed. The usual method of simply adding grain doesn't do this. The first step was to create a new layer above the image filled with mid-grey. I then added some heavy Gaussian noise to this layer (see the screen grab of the Noise dialog) and changed the blending mode to Soft Light.

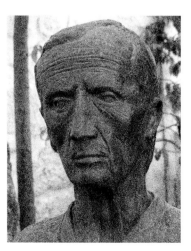

Grainy statue

To produce the tight, lumpy grain associated with film I applied some Gaussian blur to the grain layer and then applied strong Levels adjustment to increase the contrast of the grain. This resulted in the grain structure shown in the accompanying close-up. By working on a separate layer you can experiment with different methods.

Texture effects

Adobe Photoshop provides a specific filter for adding texture to an image (Filter/Texture /Texturizer). This uses any image you select as a 'bump map' to generate the textured look. It also has settings to control the lighting angle, the texture depth and the scale of the texture. By varying these settings many different effects are possible. The Texturizer filter allows you to specify any image as the source of the bump map, and this can be used to create some unusual effects. A useful method of controlling the texture effect is to make a new layer filled with mid-grey and apply the texture to this layer. Then, by changing the blending modes and the opacity setting you can experiment with different effects.

Another method of adding simulated texture is to use the Lighting Effects filter with the texture channel active. This uses a specified colour channel as a bump map.

Lamp and tower

I wanted to make this image look as if it was printed on old, heavily textured parchment. To create the parchment texture I needed an image with a random pattern and so chose the sky picture shown here. I adjusted the size of the sky image to exactly match the main picture, so that the texture filter would not create a repeating design – as it would if the sky image was smaller.

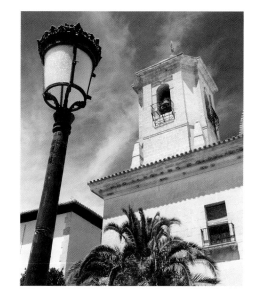

Parchment print

I used the Photoshop Texturizer filter with the sky image chosen in the Texture drop-down box (use the Load texture button first to locate the required image). Since the two images were the same size, I set the texture scale factor to 100 per cent. To create the colour and patchy stains I created a new Overlay layer filled with mid-grey and applied the Render/Clouds filter followed by the Hue/Saturation command.

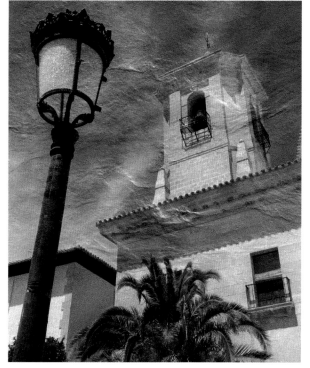

Simulating traditional film

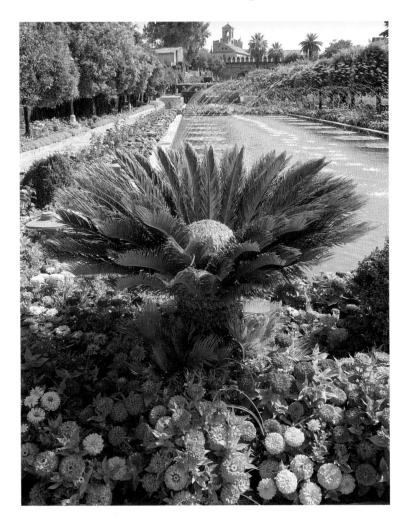

Colour original

To simulate the tonal rendition of traditional film use the conversion filters available from www.silveroxide.com. For this picture I wanted to simulate my favourite film, Kodak Tri-X.

Tri-X filter dialog

When you open the conversion filter you are presented with the dialog shown here. You can adjust the previewed image using the Brightness and Gamma sliders if desired. The histogram shows the tonal distribution of the image.

One of the important characteristics of traditional silver-based photographic film is the way each individual film type reproduces the colours of a scene. Known as the spectral response of the emulsion, this characteristic creates subtle differences in the rendition of the tones in the image of a given subject when shot on film from different manufacturers. For many photographers, it is the way a particular film renders subject colours as image tones that makes them choose one film type over another.

Unfortunately, digital camera images are always recorded on the same capture device in the camera, so this subtle visual characteristic of different films is not available. In order to provide digital camera users with the tonal variation associated with different film spectral responses, a series of monochrome conversion filters has been developed by Bill Dusterwald (available from www.silveroxide.com). These filters have been designed to convert a colour RGB image into monochrome in such a way that the tonal rendition is similar to that of particular films. For example, one of the many filters available is for Kodak Tri-X film – probably one of the most popular of the traditional emulsions. Thus, if you prefer the 'look' of a particular film it is now possible to reproduce that look on your digital camera images.

There are separate filters for all the current popular films and these can be applied to both 16-bit and 8-bit RGB colour image files. The 16-bit filters also include a histogram display, which allows you to monitor the tonal rendition. It has to

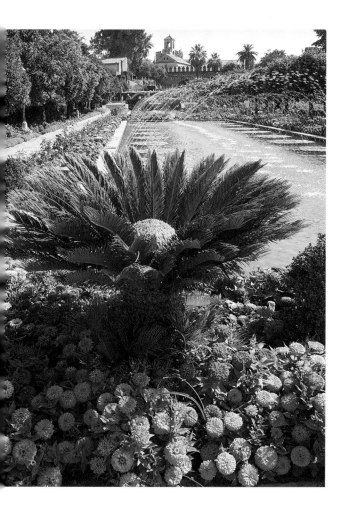

Converted Tri-X image

This is the result of using the straightforward conversion.

be said that the tonal variation from one film to another due to spectral response can be quite subtle and may not be noticed by many people looking at the image.

Another important visual aspect of traditional film for 35 mm users is how the film grain looks. Unfortunately, the filters mentioned here do not apply digital film grain to the image to match the film type, but this is easily done manually.

Simulating black and white filters

During the conversion process, the SilverOxide filter can simulate the effect on the tonal values of the image of placing a black and white contrast filter on the film camera. The result of applying a red contrast filter is shown in this version of the picture. Note how the tonal values of the flowers have been improved. The accompanying screen shot shows the filter dialog with the Red filter option chosen.

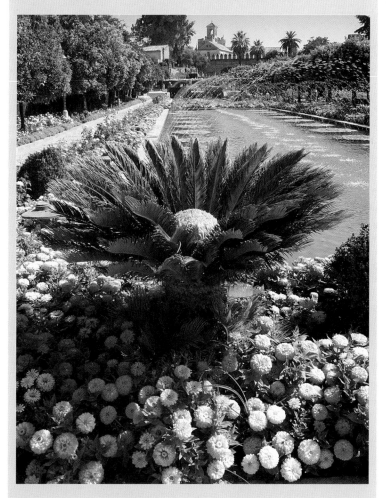

Creating digital infra-red

Many black and white photographers experiment at some time with infra-red film for the special, surreal image tones that it is capable of producing. Although infra-red light is invisible to the human eye, traditional photographic film can be made to respond to these invisible wavelengths of light. Infra-red sensitive film responds to the infra-red radiation produced by living things, such as healthy foliage, and any objects that may be radiating infra-red wavelengths.

Infra-red photographs have a unique visual quality that is dependent on the subject being photographed. Healthy foliage tends to be very light in tone, whereas blue sky, which is low in infra-red, tends to reproduce as a dark tone. With 35 mm format, the photographs also tend to have quite a grainy appearance. To simulate the infra-red 'look' using digital methods is not easy, since it is necessary to make complex selections of different parts of the image and alter the tonal values according to how much infra-red radiation might have been present. Fortunately, help is available from www.silveroxide.com, where you can obtain a 16-bit filter specifically designed to simulate the look of infra-red film.

Apply the IR filter

The layer mask is applied to the new layer to leave only the main subject. I recommend that, before doing anything to a layer you make a copy and work on the copy layer so that you can easily combine effects if desired. With each image you use it is a good idea to isolate the parts of the image to which you intend to apply the IR filter. The IR filter is then applied to this layer. The settings I chose for this image are shown in the screen grab of the filter dialog.

Statues – Cordoba

I decided this colour image would make a good candidate for the infra-red treatment since it contained good areas of foliage, a simple sky and a strong composition. Since the IR filter tends to include sky tones, the first step is to make a copy layer of the main image and define a mask (using the Extract filter) to isolate the ground from the sky. The Layers screen grab shows the layer mask in place.

The SilverOxide IR filter is used in conjunction with the Photoshop Distort/Diffuse Glow filter to recreate the unique infra-red look. The IR filter attempts to identify the tones in a picture associated with typical subjects that radiate infra-red and isolate these from non-infra-red subjects. It then alters the selected tonal values to emulate the tones of an infra-red image. Once this process is complete it is necessary to apply the Photoshop Diffuse Glow filter to add the glowing effect of the lighter infra-red tones. Finally, if you want to simulate 35 mm infra-red, you can add film grain to the image.

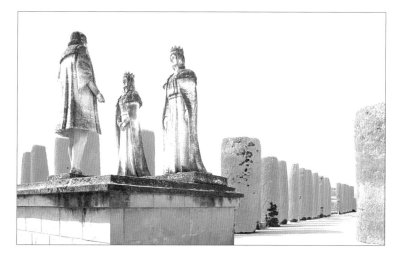

Apply diffuse glow

The IR filter does a great job but, as seen in the foliage in this image, it can leave areas of the subject untouched. Therefore, before applying the Diffuse Glow filter you need to use the clone tool to correct these areas. Next, apply the Photoshop Diffuse Glow filter (Filter/Distort menu). The settings you choose for the filter depend on what you want the image to look like. The screen grab shows the settings chosen for this image.

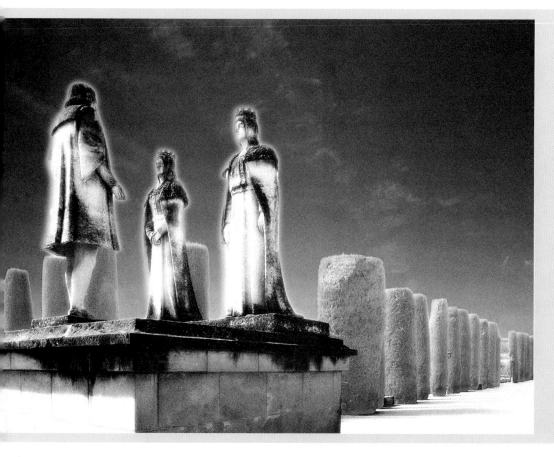

Infra-red statues

The final image shown here has had a glow placed around the statues to give them an even more surreal appearance. I also darkened the sky and added some noise to make it blend in with the grainy effect on the main subject. This simulates the use of 35 mm infra-red film. The final layers are shown in the screen grab.

Image toning and colouring methods

The toning of monochrome prints is a complex but fascinating area of traditional photography. Traditional chemical toning has two main purposes: to increase the stability of the image and to add colour for aesthetic enhancement. The various methods available for traditional toning can produce unusual and beautiful results.

In digital monochrome work, toning has only one purpose and that is to add colour to the image for aesthetic enhancement.

There are various ways to add colour to a digital monochrome image and which method you choose depends on what you are trying to achieve and the capabilities of your image editing software. Many people will want to simulate traditional techniques to obtain results such as those achieved using duotone, split-toning and multi-toning. These techniques utilize a wide variety of different chemical and dye-based solutions, such as selenium, gold, copper and even tea and coffee. Although each of these chemical procedures can produce colour in the image, many of them also affect other aspects of the image, such

as the tonal balance and/or the rendition of detail. For the purposes of digital toning our main concern is the colour changes that occur since we are not dealing with a chemical process (although colour manipulation of a digital image may also have an effect on the tonal scale). It is often a good idea to examine traditional toned prints to determine the visual qualities of the toning process used in order to be able to establish the best way of achieving the same results digitally.

Although specialist ink sets are available for achieving toned inkjet prints, there is no reason why excellent results should not be obtained with the manufacturers' pigment-based colour inks, since it is claimed they have the same archival qualities as some of the specialist pigmented inks.

Duotone

High-quality photo-mechanical reproduction of fine monochrome prints for use as fine art prints or in 'coffee table' books often achieve a better tonal reproduction and subtle use of colour using a process known as duotone. Duotone, although

Monochrome image

The original colour image was converted to monochrome using the channel mixer. This allows tonal adjustments to be made based on the original colours. It is like using mono contrast filters on the camera.

Single colour toning

A simple method is to place a new layer, filled with a colour, above the image (see screen grab). This is like traditional dye-based toning. Set the colour layer to Overlay and it will apply the colour but retain the tonal values of the image.

Untoned image (above)
Start with a monochrome image in RGB mode.

not strictly a toning process, allows the application of colour in varying degrees across the tonal scale of the image. Additional colour can be introduced using tritone or quadtone processes. Adobe Photoshop has extensive facilities for producing these effects.

Split-toning
Split-toning refers to the technique of allowing the colour change to affect only a restricted portion of the tonal scale of the print. Usually it is the mid to light tones of the image that pick up the colour, leaving the darker tones unaffected. This gives a unique 'look' to a print. Split-toning is easily achieved digitally, since you can apply colour to any section of the tonal range of an image.

Multi-toning
The technique of multi-toning uses a combination of different toners to produce more than one colour in the final image. Each colour usually affects only part of the tonal range, producing an unusual multi-coloured result. This effect is easy to achieve digitally, using layers and selections.

Dye 'toning'
Dye-based toning 'stains' the emulsion of a traditional print to produce the colour rather than affecting the image chemically like real toners. This tends to produce an even application of colour across the whole image. It is easily

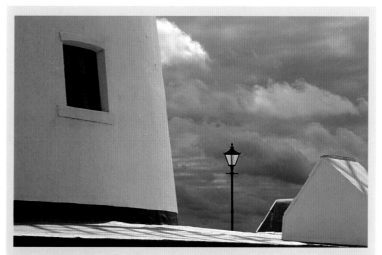

Split-toning
To produce a split-toned effect select the light tones of the image to restrict where the colour is applied. Then create the Hue/Saturation adjustment layer.

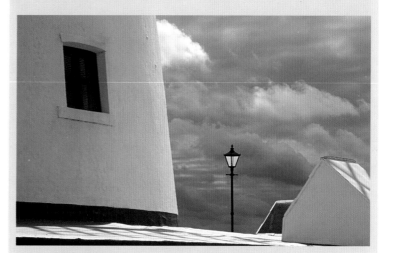

Multi-toning
For a multi-toned effect use different selections for each colour when creating the Hue/Saturation adjustment layer. Here I used three adjustment layers, two with different selections to mask the colours.

simulated digitally by filling a new layer with the desired colour and changing the blending mode to 'colour'.

Basic Photomontage

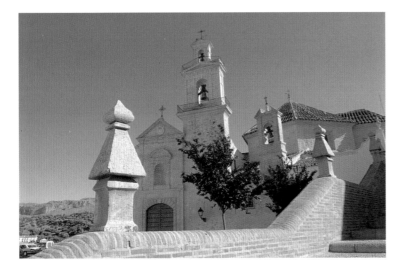

Church – Antequera

I liked this view but felt that the right side was too busy and detracted from the church tower in the centre. I decided to add a new wall and post as a dominant foreground frame.

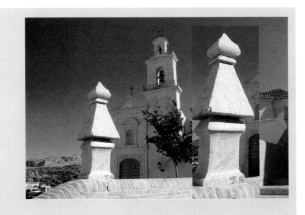

Gathering the components

I had shot another similar view with the post on the left much bigger in the frame and so decided to use that for this picture. The first step was to cut and paste the new post from the other image into a new layer above the main picture. I also added a Channel Mixer layer to control the conversion to black and white. The Layers palette screen grab shows how the layers are arranged.

Photomontage has been a popular method of creating complex pictures from the earliest days of photography. A montage is created by combining together several individual picture elements into a coherent composition. Artists have used montage for everything from recreating the complex religious paintings of the Renaissance to political satire and propaganda (as used very effectively by the German artists during WW2). In fact, the first exposure for many children to Art is to cut out pictures and glue them together to make a montage.

Traditionally, multi-image pictures are either created by multiple exposures in camera or by multi-printing two or more negatives in a darkroom. Both methods require skill and experience to achieve excellent results. The same applies to digital montage, editing skill combined with artistic interpretation is essential to achieve the desired image.

The relative ease of digital montage is made possible by the use of layers. A layer is like a transparent surface on which you can place or draw image elements. Several layers are placed in a stack, one above the other, and manipulated individually (or collectively) to achieve the desired result. Each layer can have it's opacity adjusted to control the transparency of the image elements on it. Also, each layer can have one of many different blending modes applied to it to alter the way the image content interacts with the layers below it in the stack.

An important feature of layers is that you can add a layer mask to a layer. A layer mask allows you to selectively hide or reveal parts of the image on the layer without actually altering the image. This is a powerful tool for working with montages.

In this way, using layers and the manipulation tools, anything you can imagine can now be created as a picture.

Integrating the components

The next step was to rotate the new post to achieve the perspective I desired using the Edit/Transform/ Rotate command. Once this was done it was necessary to hide any parts of the new layer that were not required. This is achieved using a Layer Mask (Layer/Add Layer Mask command) which allows you to paint out areas you do not want visible but without deleting parts of the actual image layer. This allows you to make corrections if necessary. Painting with black hides detail whilst painting with white reveals previously hidden detail. The image was also cropped to shape. The Layers palette screen shot shows the final layer mask.

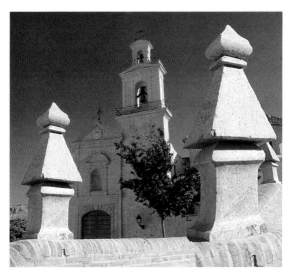

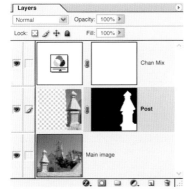

Church – Antequera

The final step in the montage was to create a new section of wall in the foreground. I selected and copied the part of the wall below the new post to a new layer (Layer/New Layer/via copy). This new section was then rotated and distorted to create the appearance of a matching wall. I used a Layer mask to refine the shape of the wall section. When finished this was combined with the post layer. The distracting detail on the right of the picture was replaced using the Clone tool. Finally, local tone adjustments completed the image.

Advanced multi-image techniques

Photo-montage can be as simple or as complex as your image visualization demands. Many photo-artists bring together images of everyday objects and scenes into resource libraries, which they later use to create new montage work. Others visualize the image first and then collect the necessary material for that particular image (as I did for the image shown here).

To collect montage material use a digital camera and/or a scanner to create the necessary digital files. A flatbed scanner can also be used to scan real objects directly on the scanner, adding a further dimension to your montage. Once the elements are digitized in this way we can use layers, and any of the advanced options for working with them, to simulate a 3D montage.

There are two ways to approach this type of project: either plan the image in advance based on a preconceived idea (perhaps to express how you feel about something in real life) or simply assemble a variety of different elements and experiment to see where it takes you. Which method you choose will depend on how you feel about the project in hand and your personality.

When scanning or photographing scenes and objects for a montage project it is essential that each individual image element has sufficient digital data to allow resizing and other, possibly extreme, manipulations. For example, it is very frustrating to try to increase the size of an element, only to find that the quality after resizing is not good enough. Scan or photograph all the elements with the final print size and resolution in mind.

Gather all the elements for the composition on separate layers in one file. Use layer masks to isolate individual parts and change blending modes and opacity settings as required to combine the elements into one image. You can also use various editing tools, such as cloning and gradient, to manipulate the elements locally.

1 Dam scan

Since the image was to be made from one negative, the first step was to scan it twice to make the important areas, the dam and the sky, appear as I wanted them. Making two scans and adjusting the scanner settings for each area produces better information in the final digital files. This is the basic scan to retain information in the dam.

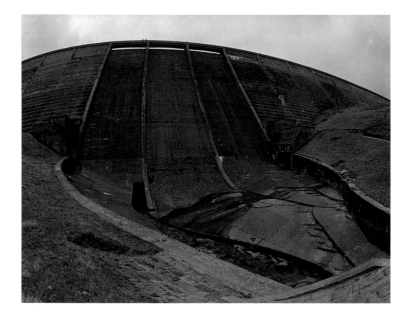

2 Sky scan

Without touching the scanner (so as not to move anything), the settings were changed to produce the tonal range required for the sky. As long as nothing moves, the two scans should be easy to align on individual image layers.

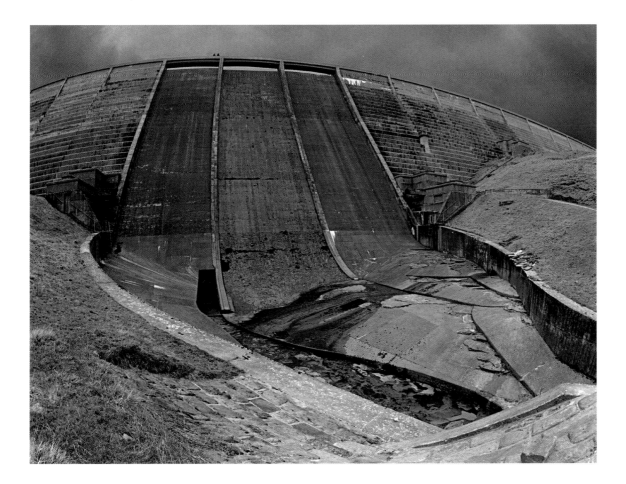

3 Blending the scans

Opening the two scans from the dam negative and copying each to a separate layer in a new file in Photoshop allowed them to be combined. Careful use of layer masks and retouching with the clone tool produced a perfect combination.

Layers palette

This is the Layers palette for the combined scans. Note the use of layer masking, both for the image layers and for adjustment layers (to fine-tune contrast). The layer mask on the dam layer is also changing the gap size where the water pours over the dam (see detail on next page).

4 Water scan

This is the basic scan of the water from another negative to be used in the final image. The black rectangle shows the actual area of water used later.

5 Changing reality

This detail shows how the top edge of the central water flow section has been lowered in relation to the levels of the sections at each side. It now appears logical that water would flow over the central section first.

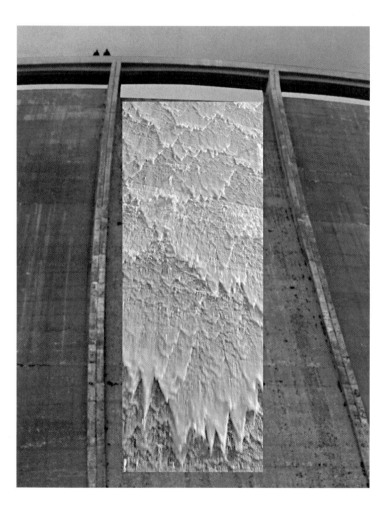

6 Water added

The selected water area is placed on a new layer and positioned ready for manipulation.

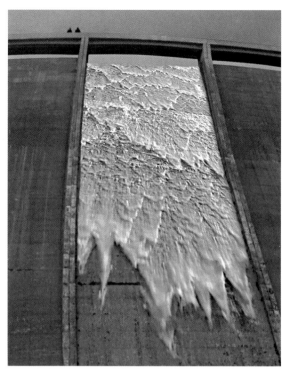

7 Water reshaped

Using the Distort tool, the water has been reshaped to fit the flow channel. A layer mask was used to hide areas not required and to fine-tune the shape of the water around the edges. The Gradient tool was used while in Quick Mask mode to create a graduated selection down the water. Applying the Blur filter to this selection produced a differential blur on the water to simulate the acceleration of the water flow. A Drop Shadow layer style was then applied to produce the subtle shadow under the front edge of the water.

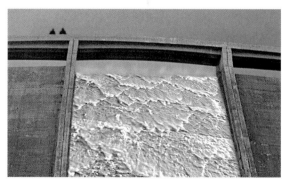

8 Water vapour

This detail shows the impression of water vapour where the flow of water begins. This was created by painting with a low opacity white brush on a layer above the water. It is this attention to realistic detail that makes this sort of image seem plausible.

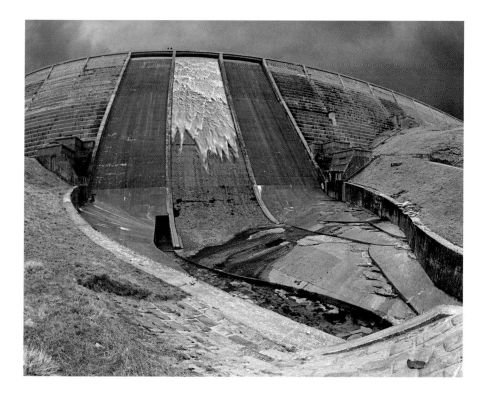

Compositing complete
Here all the major components have been combined, and the image is now ready for more local tone adjustments (burning and dodging) to balance the composition. Do this by creating a new layer filled with mid-grey in Overlay blend mode, and paint with different opacity brushes rather than using the burn/dodge tools, since this method allows corrections and doesn't alter the image data directly.

Gushing dam
The final image with all local tone adjustments complete and colour toning added. The sun effect was added to balance the composition and give the sunlit water more reality.

Enhancing images

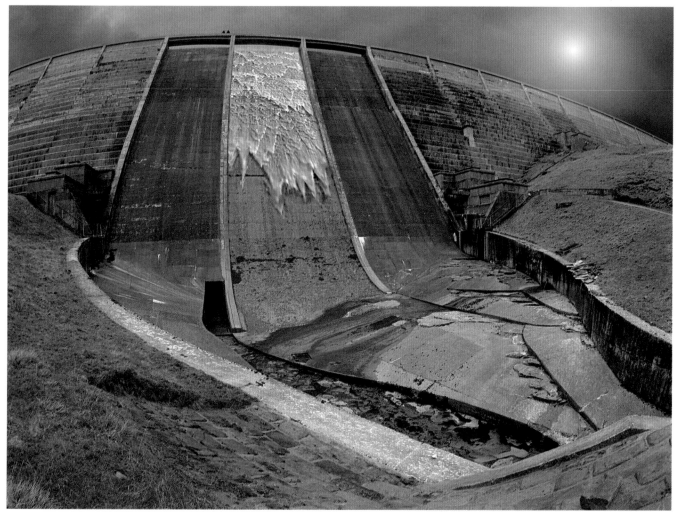

Panoramas

Panoramas have always been a source of fascination for photographers and picture viewers alike. Previously, special equipment was required to create a panoramic image but now digital image software makes it easy to replicate this effect. Although there are specialized image programs that provide excellent facilities for creating panoramas, sometimes the nature of the subject makes it better to do the job manually. The architectural night scene shown here is such a subject.

To obtain the required images of a scene for a panorama it is important to use a tripod so that all the images can be aligned easily in your editing program. By making sure the tripod is perfectly level you will also minimize lens distortion of the subject. To provide more flexibility later, I find it useful to make two or three different exposures of each part of the scene, since the brightness of the light usually changes as the camera swings from one side of the scene to the other. The different exposures make it easier to obtain the right overall tonal balance when blending the different images. When making

sectional images of a scene, allow a good amount of subject overlap on each frame. Around 20–40 per cent is usually sufficient to allow the images to be combined easily.

Choose the exposure of each part of the scene you want to use and open the first two of the sequence in your image program. Create a new file the same height as the images but twice the width. Copy the first two images, in the correct order, to this new file on separate layers. Next use the Move tool to position the images so they overlap closely. Reducing the layer opacity of the top layer makes this easier. Now use the Image/Distort command on the top layer to make the images fit as accurately as possible. (When using the Distort command, zoom out of the image in the window so you can move the distort handles outside the image area.) This method makes it possible to remove unwanted lens distortions. Once the distort command has been applied it may be necessary to use the Clone tool to fill in blank areas at the sides of each image.

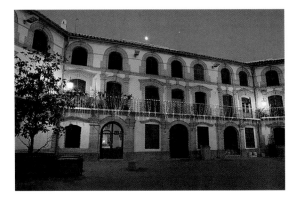

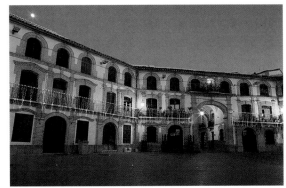

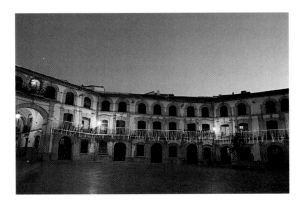

1 Recording the subject

The number of images needed for a panorama depends on how much of a scene you want to record and the amount of overlap you use. These are the first three images in the sequence for a panorama of a Spanish plaza shot at dusk.

Here the first two images have been copied to separate layers in a new file. The Move tool was used to position the second image roughly over the first. Note the reduced opacity of the top layer to help with positioning (see the Layers screen grab). Since this subject was shot with a wide-angle lens pointing slightly up, the subject distortion is severe.

Next, change the opacity of the top layer back to 100 per cent and add a layer mask to this layer. Now use a black soft brush to paint on the layer mask to hide unwanted parts of the image layer. Alter the size and opacity of the brush as required. This final touch allows you to make a very accurate blend of each image.

For each of the other images in the sequence, increase the size of the canvas of the panorama image as required and copy the new image to a new layer. Again, use the Image/Distort command to combine each image. Continue in this way until you have completed the panorama.

3 Correcting distortion

Using the Distort tool correct the alignment of the verticals and reshape each image so that all the elements match closely. If necessary use the clone tool on each layer to add detail in any areas left blank by this correction.

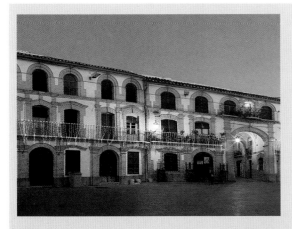
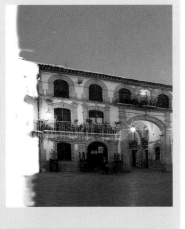

Completed blend

Here we see the result of combining three of the images for the panorama. Note how the distortion has been removed and the images seamlessly blended together using the layer masks. Once all the layers are in place adjust the tonal balance of each image so the composition is tonally balanced.

Refining the blend

To refine the way two layers combine add a Layer mask (see screen grab) to the upper layer and use a soft brush to hide unwanted detail. It is a good idea to make this layer mask follow obvious lines of detail since this helps to fool the eye. The inset image shows how this has been done here.

Correcting the sky

Here we see the result of different brightness levels in the sky tones of the image. This was caused by rapidly changing light, use of the wide lens and varying the exposures. The earlier tone correction fixed the buildings but not the sky. The easiest solution is to replace the offending sky with a new one.

Gradient sky

I added a new layer above the rest and used the Gradient tool to make a Radial gradient to match the original sky. I then made a selection around the roof tops and used this to create a Layer Mask for the new sky that would reveal the buildings. This is a section showing the new sky.

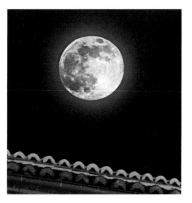

Moonlight

The moon was visible in the original scene but I knew that it would not record well as can be seen in the original images. Using a better moon image on a new layer I was able to finish the composition. A mild glow was added to the moon to simulate the effect seen by the eye when viewing a full moon.

Plaza by Night

The final panorama which gave a 360 degree view of the plaza is actually seven feet long so I have cropped the image severely to fit this book. The blue tone was added by converting to RGB and using the Hue/Saturation method.

Sharpening technique

Digital images, whether originated with a digital camera or by scanning film, are inherently unsharp due to the technology used. Therefore, at some point it will be necessary to sharpen the image prior to printing. There are different opinions concerning the point in the digital process at which sharpening should take place.

A system of systematic sharpening has been proposed by Bruce Fraser, based on the principle that there are three distinct phases of the

Old shop door

This is the image I want to sharpen. It was taken using a Fuji S2 Pro digital SLR and saved in the camera in the RAW file format. In this way I can see just how soft a digital image starts out.

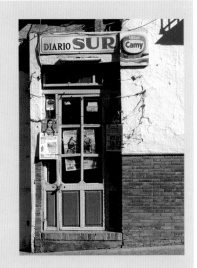

1 Capture sharpness

First, if the image is in colour, choose the channel that contains the most contrast in the details and make a copy in a new channel. This will be used to create a mask. If the image is not in colour simply copy an existing channel. Apply the Find Edges filter to this channel then use the Levels command to increase the contrast further. Now invert the tones using the Invert command. Go to the original image layer and make a new copy layer. Change the blending mode to Luminosity. Now load the mask from the new channel (Ctrl/Click on the channel) and then apply a layer mask to the copy layer. Next apply Unsharp Mask to the copy layer. The effect will be very subtle. Finally, use the Layer Options to reduce the sharpening at the lightest and darkest tones (this concentrates the effect on the middle tones and reduces haloes). The various settings are shown in the screen grabs.

digital process at which it may be beneficial to sharpen the image. According to this method Fraser calls the three stages capture sharpening, creative sharpening and output sharpening.

The first of these, capture sharpening, concerns itself with the problem that all digital capture devices produce inherently unsharp images. Fraser recommends that a small amount of selective sharpening should be applied to the image prior to any additional work to improve the effects of later enhancements.

The second stage, creative sharpening, is concerned with applying sharpness for aesthetic reasons. This would be the stage at which you would decide which parts of the image would be improved with additional sharpness (or even additional blurring).

The third stage, output sharpening, is designed to produce the correct amount of sharpening based on the actual output device being used. For example, making an inkjet print from an image may require a quite different amount of sharpening to that needed if the same image was to be reproduced in a book using a modern printing press.

This three-stage sharpening system has great merit since it allows you considerable control at each of the three stages and can be adapted on an image-by-image basis to achieve just the right amount of total image sharpening. The system makes use of channels, layers and layer masks and the Luminosity blending mode to control each stage. Since the Luminosity blending mode is used, the image must be in RGB mode for this to be available. If your image is in greyscale convert it to RGB before starting.

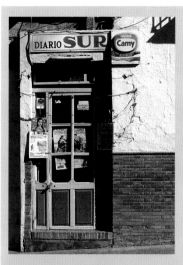
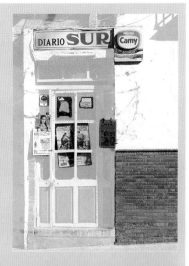

2 Creative sharpness

The second stage is to apply sharpness to areas of the image by copying the original image layer to a new layer set to Luminosity blend mode. Apply the USM using the following settings: Amount 500, Radius 0.2 and Threshold 0. Next, add a layer mask using the Hide All option. Now, using a white paintbrush on the layer mask, you can paint over the areas you want to have sharpened. Use different opacities of brush to vary the amount of sharpness applied. The final layers mask is also shown here, together with the Layers palette.

3 Output sharpness

The final stage is to apply the output sharpness based on your printer. Flatten the image, make a new copy layer and set the blend mode to Overlay. Apply the High Pass filter to this layer and then change the layer options as before to remove the effect from the light and dark tones. Don't worry too much if the image looks over-sharpened: print it and check the printed image.

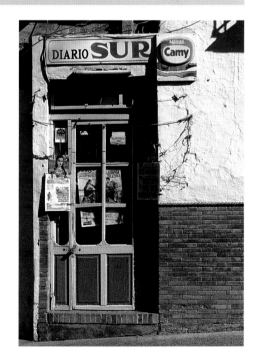

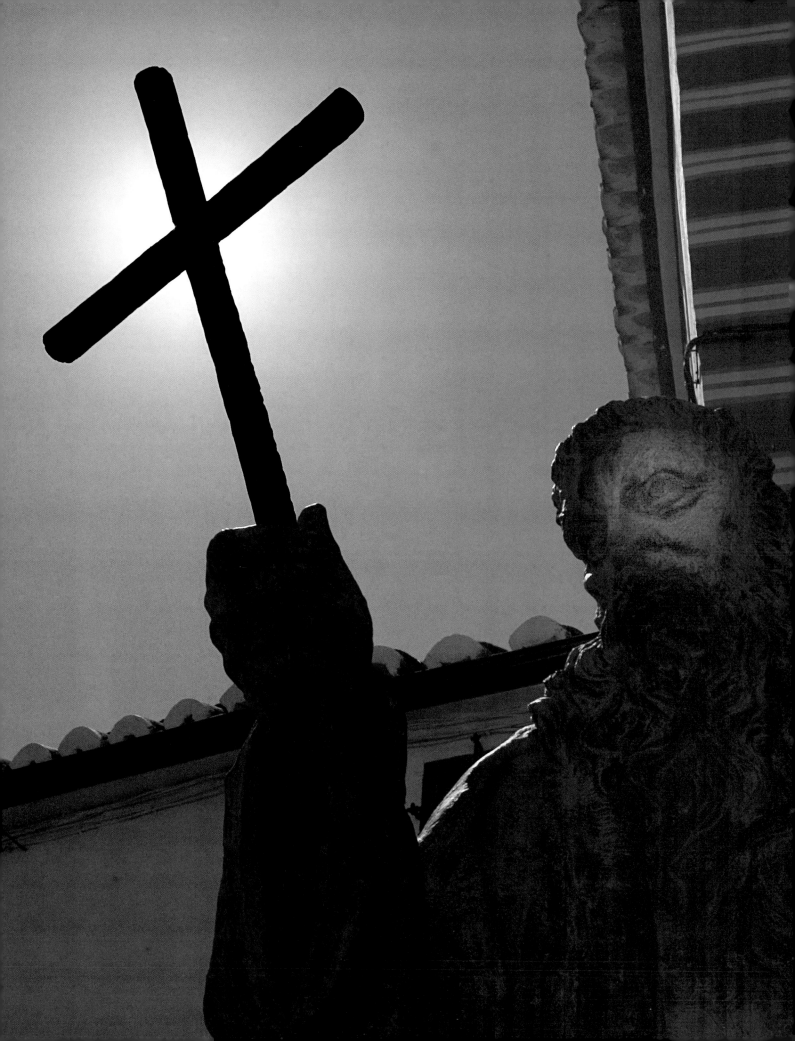

Chapter 4
Outputting images

This final chapter may well be considered the most important for many traditional monochrome photographers moving over to digital. The two most important quality issues for the serious photographer searching for high-quality results are the input (scanning and digital camera capture) and output stages (printing). In this section we look at the issues relating to obtaining high-quality prints from digital files.

The section starts with a discussion on printer calibration followed by the steps required to make a digital inkjet print. Next we look at making contact sheets (a traditional method of viewing images that have been stored in files or on disks that still has a place in the digital world). Finally, we take a look at digital inkjet printing with various media and inks.

For many people, the thrill and anticipation of seeing a new print image appear in the developing dish will never be matched. However, you will find a new sense of excitement (and often frustration) when you start to produce your first serious monochrome prints using an inkjet printer. You will really start to appreciate digital printing when you see how easy, and quick, it is to make fine adjustments to a print or to simulate and explore the previously 'dark art' of print toning. With digital inkjet printing you can have an exciting new print finished in a few minutes ready to display on your wall or in a portfolio, without the tedium of the darkroom process. And once the image is finalized and saved you can make as many exact copies as you wish, either now or at any time in the future, simply with a few clicks of the mouse buttons.

Sun and cross (opposite)
Digital printing now offers serious black and white photographers more options than traditional darkroom printing. Even extremely low-key subjects like this can now be printed to archival 'fine print' quality on desktop inkjet printers.

Printer calibration

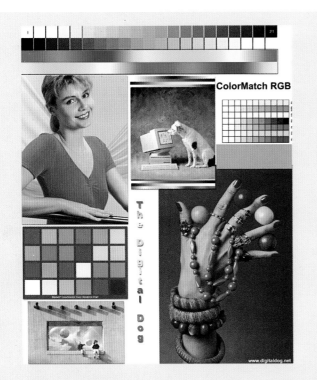

ColorMatch RGB

The Digital Dog

www.digitaldog.net

Standard test target

This is the test target available for free download from the Digital Dog website. As shown here, the target includes a range of different colour samples, a portrait for flesh tones, a black and white image and neutral grey scales.

Print command

The printer driver controls are accessed from the Print command dialog shown here. If you have more than one printer, first select the relevant machine from the drop-down list. Next, click the Properties button to move more deeply into the driver settings.

Properties dialog

To access the colour controls click the Custom radio button and then click the Advanced button. This opens the advanced settings dialog.

One of the biggest frustrations for photographers producing their own inkjet prints is printer calibration. Since any calibration, whether professionally done using an IT8 target and colorimeter or from your own test prints, applies only to one paper and ink set combination, it can become very expensive and/or time consuming to use several different types of output media. Unfortunately, this is a situation we have to accept.

As with other imaging hardware, the best option is to have a profile made from a standard IT8 original printed with the chosen printer and media. If this is not feasible, you can discover your own personal settings using either a Curves adjustment layer or the printer driver's own colour management settings. Manufacturers of specialist ink sets usually provide either profiles or adjustment curves for their inks with specific types of paper for use with a certain printer.

In the absence of third-party profiles or curves you can do your own calibration. Start with a good test image (you can download the versatile test image I used here from www.digitaldog.net). First, decide whether to use a Curves adjustment layer or the printer driver settings: never mix the two as this simply introduces redundancy. The former method is harder to implement but offers greater control.

With Epson printers (and most others), the printer driver colour controls have sliders for brightness, contrast, saturation, and the three ink primary colours of cyan, magenta and yellow. To start, simply make a small unmodified work print with all the settings at zero (see pages 116–19). Assess this print and adjust the required settings as appropriate. For example, if the work print is too dark and has a cyan colour bias, increase the brightness, reduce the cyan settings and make another print. Continue in this way until the print is perfect and then save these settings to make a profile for future use.

To obtain the best from your printer when using normal colour inks for printing black and white or toned pictures, make sure you use the colour settings as calibrated above. This will produce the

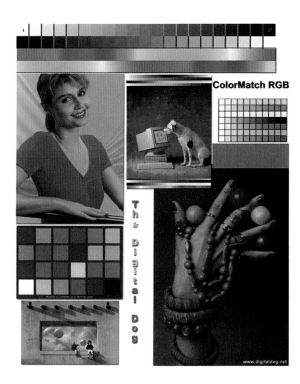

ColorMatch RGB

The Digital Dog

www.digitaldog.net

Print comparison

Above is the first test print and, below, the corrected final print using the settings shown in the Advanced dialog screen grabs. Bear in mind that these prints have been scanned so the colours, especially the rich magenta, have not reproduced well here. In the calibrated print the colours were very close to those of the original Digital Dog file.

ColorMatch RGB

The Digital Dog

www.digitaldog.net

Advanced settings dialog

Start the first print test by selecting the media type, the printing resolution (1440 dpi is more than adequate), the gamma setting and the Colour Controls radio button. Assess the print and make adjustments to the colour controls for the next print. The settings I needed to make the two prints on this page are shown in these screen grabs. Once you are happy with the print, save the settings with a relevant name using the Save Settings button.

Loading your personal settings

Next time you wish to make a print simply select your saved settings from the Properties dialog custom drop-down list.

smoothest tones (using only the black setting reduces the smoothness of the tones) although it may be very difficult to obtain a truly neutral print. For truly neutral prints or to avoid photo-metamerism (where colours do not match in all lighting conditions), it is necessary to use one of the range of independent monochrome ink sets.

Bear in mind that print colour in traditional black and white darkroom printing is an aesthetic consideration and this is equally true of black and white digital printing. You can experiment by slightly changing the calibrated settings in the printer driver to produce different but very subtle image colour. This print colour should be a mere hint and not as strong as a truly toned print.

Making a print

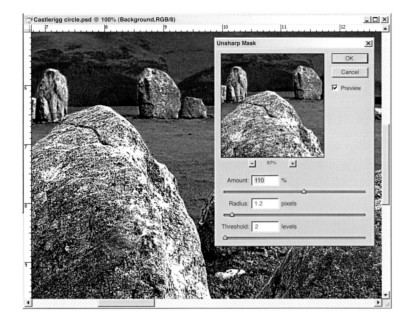

Paper size dialog
After sharpening the image but before resizing it for printing it is necessary to set the paper size to A6 (or the size you are using for the work prints).

Unsharp mask
Flatten the image and, with the image displayed in the window at 100 per cent, use the USM dialog to apply image sharpening. With the Preview box checked, the sharpening effect will be shown on the main image.

If you have a digital system in which each piece of hardware has been professionally profiled so that the colour management is optimum, it should be possible to produce an almost ideal print that closely matches the displayed monitor image. Remember that a printer profile applies only to one ink and paper combination, and that separate profiles are needed for each combination of media you choose to use. Thus, if you like to experiment with different papers and inks it can be very expensive to maintain a fully profiled system.

On a system that hasn't been professionally profiled or calibrated visually using the method on pages 114–115, it will be necessary to make small work prints of each image before committing to a finished 'fine print'. This is not difficult to do and after gaining experience with the materials you use most it becomes possible to reduce the number of work prints required.

There are three ways to control the tonal range and colour balance (for toned prints using normal colour inks or toneable b/w ink sets) of the final print: use a profiled system, use the printer driver colour adjustment controls to make your own calibration, or use adjustment layers in your editing program. If you are using a professional profile or adjustment layers, turn off the printer driver colour controls. If you are using generic profiles from the media manufacturers, or you simply need to make changes, use adjustment layers for the finest control.

The following steps are required to make the first test print on an *uncalibrated* system:

Save a master copy and reduce to 8 bits
Obviously, the first step is to make all the enhancements to the image that you desire and then save the file *without sharpening* in the TIFF or PSD format. Keep this as your master copy. It is a good idea to duplicate the image (Image/Duplicate command) and close the original to keep it safe. If the image is in 16-bit mode use the Image/Mode command to convert it to 8-bit as most printers require only 8-bit image files.

Flatten and sharpen the image
If the image has layers, flatten it prior to sharpening and printing. Display the image at 100 per cent and sharpen it using USM or whichever

Image size dialog

Clear the Resample Image check box (ringed in red) in the Image Size dialog and change the resolution of the image. Higher resolutions make the image print smaller. Make sure that the image details at the top of the dialog (ringed in red on the screen grab below) do not change as you alter the resolution. If they do it means the Resample Image box is still active.

method you prefer. Remember that the image can appear over-sharpened on the monitor but print perfectly (you need to experiment to determine the maximum sharpening you can apply before the print is adversely affected). Also, as a general rule, larger image files need more sharpening.

Change resolution without resampling

Now you need to make small work prints (I use A6 paper cut from A3 for economy) to obtain the correct tone and colour. Set the paper size first and then change the resolution of the image

Print preview dialog

The Print preview dialog shown here is where you tell the driver how you want the print to be positioned on the paper and set additional options. As an example, in the screen grab below. I have used the Background button to make the paper colour change. This colour would be printed automatically (not that I would want that, of course).

without resampling (use the Image Size command in Photoshop and clear the Resample Image box) until the image is the right size for the paper. Changing the resolution without resampling alters the print size but doesn't affect the file size, which is essential.

Print and Print Properties dialogs

From the Print dialog click the Properties button to go to the Properties dialog. From here you can access the advanced settings dialog where you specify the colour control you want. Since I was using adjustment layers I switched off the driver's colour system.

Cleaning the print head

Before making the first print, it is essential to check that the print head nozzles are clear and not producing gaps in the print lines. Use the printer driver Utilities dialogs, as shown here, to test the printer. Any clogs in the nozzles will result in visible lines on the printed image.

Nozzle Check

Good

Cleaning needed

Compare the printed pattern with the sample above. If any segments are missing in the printed pattern, click the Clean button. Otherwise, Click the Finish button to quit.

Clean Finish

Set the paper size, image position and printer profile

In Photoshop, if you have a generic printer profile select this in the Print with Preview dialog box. In this dialog box, you may also set the paper size, change the position of the image on the paper and choose other options such as whether to print a black key line around the image. If, after setting the paper size, the image is too big or small, go back to the Image Size command and adjust the resolution setting until the image fits the paper. When ready, click on the Print button.

Select the media, print resolution and colour settings

Next, use the Print command dialog box to set the various print options. Click the Properties button from the Print dialog. In the Properties dialog click the Custom radio button of the Mode section and then click the Advanced button to access the driver settings. In the Advanced dialog, first choose the paper type according to the paper manufacturers' recommendation. With the Epson printer driver the media chosen dictates the range of printer resolutions: set this to at least 1440 dpi. You may like to experiment with the printer's resolution setting to ascertain whether the highest setting of 2880 dpi is really necessary, as it can take considerably longer to print using the highest resolution. In my experience, with Epson printers, printing an image at 1440 dpi rather than 2880 dpi produces a virtually identical print in far less time.

Since you are using adjustment layers to control the print output, make sure the Colour Management option is set to No Colour Adjustment. You do not want the printer driver altering the colour values you send to the printer.

Make work prints

Before making the first print, check that the printer nozzles are working correctly by using the printer driver utilities to print a test pattern.

Now make a straight work print with no adjustment to see how an unmodified print appears. Assess the tonal values of this first test print (and the colour if it is a toned image) and determine if any improvements are needed.

To make changes, add a Curves adjustment layer to the image and modify the individual curves to correct the image. Note that minor changes can make a big visual difference to the print, so start with small adjustments. If you are not comfortable with curve adjustments, create a Levels adjustment layer to control tonal values and a Colour Balance adjustment layer to alter the colour rendition (the image needs to be in RGB mode, not greyscale).

Now make another work print using exactly the same printer settings as before. It is vital that nothing else is changed, otherwise it will be impossible to control the results. Assess the second work print and make any further corrections to the adjustment layer. Continue in this way until you are happy with the print.

Once the adjustment layer is correct it can be stored separately in its own file, to be opened and copied into a new image at a later time. Alternatively, in Photoshop you can create an 'action' script to make the necessary adjustment layer automatically.

Print the 'fine print'

When ready, use the Image Size command to change the resolution back to the required setting for a full-sized print. You also need to change the paper size accordingly. Use the Print with Preview to position the full-size image on the paper and make the final print.

Adjustment layers

After first printing the unmodified work print, use adjustment layers to make changes to the image between test prints. Here I used a Curves adjustment layer to reduce a green cast in the shadow portion of the image. Alternatively, use both the Levels and Colour Balance adjustment layers to control the print changes. The Levels layer is used to control the brightness and contrast, while the Colour Balance layer controls the image colours.

Stone circle

If desired, the printed image can be intentionally toned, using the adjustment layers to apply a colour cast. It is necessary to convert a greyscale image to RGB for this to work. This manipulated image of a stone circle has had a warm tone applied to it.

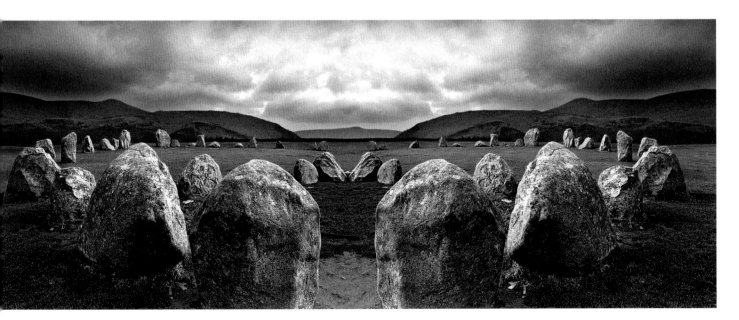

Creating contact sheets

Contact Sheet II

This is the dialog that appears when you initiate the Photoshop contact sheet command. First, choose the folder that contains the images from which the contact sheet will be generated. In the Document section specify the size of the contact sheet, the resolution and the colour mode (i.e. RGB or Grayscale). If you want to adjust the individual images of the contact sheet later, uncheck the Flatten All Layers box. In the Thumbnails section, specify how many rows and columns you require. This will dictate the number and size of the images on the sheet. Last, select whether to print the filename as a caption under each image.

Traditional contact sheets, made by placing negatives in contact with printing paper in the darkroom to produce a positive visual reference, have always been a mainstay of the black and white photographer's filing system. However, for many photographers, producing contact sheets (or proper proofs in the zone system) has always been rather a tedious (and often neglected) chore. Fortunately, you can now produce contact sheets of your digital images and scanned negatives with relative ease.

It could be argued that, with the availability of digital image cataloguing software, physical contact sheets are a thing of the past. This is simply not so, as the benefits of contact sheets are still relevant in today's technological age. Contact sheets are a great visual reference for images stored on external media (such as DVD) and in many cases can be more practical to utilize than the computer filing system.

Some image editing programs, such as Photoshop, have facilities for producing digital contact sheets built in, or you can buy dedicated software to perform a similar task. In Photoshop, use the File/Automate/Contact Sheet command to launch the dedicated system for making contact sheets.

Of the other programs in common use, Paint Shop Pro can print thumbnail images of the contents of a directory from the browser window, and in Picture Window Pro the Layout transformation can be used to create contact sheets (although this is a rather tedious and less than intuitive process).

The contact sheet

After you press the OK button in the command dialog, Photoshop will process each image and generate the necessary number of contact sheets based on the total number of images and how many images will fit on one sheet. Once the sheet has been created, the canvas can be resized and the type tool used to place additional information on the sheet. It is a good idea to create a master file of the correct size, containing a layer with all the necessary headings already in place. This layer can then be moved on to each new contact sheet as required, thus saving repetitive work.

Using contact sheets

As this picture shows, A4 or 10 x 8 in contact sheets can be used as visual references for your picture files or made to fit DVD cases as visual reference covers. Make the images for the DVD cases quite small, to fit more on the cover, or make several sheets to store inside the cases.

Exploring inkjet papers

The world of inkjet printing is, like the traditional darkrooms of 50 years ago, awash with a wide range of printing papers. Digital inkjet printing enables photographers to experiment as never before with various paper weights, surface finishes and even non-paper media such as canvas to achieve just the print they desire.

Fine-art and other photo media are specially designed and coated to provide optimum quality for use with inkjet printers. Each type will have its own individual characteristics when used to print on a specific machine and with a specific ink set. As with traditional photographic materials, it takes time to become accustomed to the visual qualities and subtleties of a particular paper and ink combination.

Inkjet papers follow the traditional printing industry nomenclature and specifications of size and weight. The sizes usually follow the international 'A' or 'B' series and the weight is specified in grams per square metre (gsm). The weight indicates the thickness of the paper, e.g. basic plain inkjet paper is 80 gsm whereas high quality fine-art media can be anywhere between 200 gsm and 310 gsm. One aspect of paper weight to be aware of is that the printer manufacturer will specify a maximum recommended weight, and using anything heavier may cause excess wear or even damage to the print head and invalidate any warranty.

Inkjet papers for photographic printing are available in two basic forms: resin-coated in glossy, semi-matt or matt finishes and high-quality fine-art papers. Fine-art papers are usually made from cotton or wood pulp and have a neutral pH, making them suitable for archival printing. They also come in a range of surface finishes, from smooth to textured, and may have an inherent colour from white to cream/ivory. This allows for widely differing tastes and applications. One big difference between matt finish inkjet papers and traditional photographic matt papers is that inkjet papers do not reduce the visual appearance of tone and detail.

A good way to experiment with the various inkjet media available from different manufacturers is to buy one of the many sample packs sold by professional suppliers. These usually contain one or two A4 sheets of each type of paper from a particular manufacturer.

For the more experimental it is worth exploring inkjet printing on non-coated papers, such as rice paper, and other suitable media. Remember that the type of paper can have a dramatic impact on the rendition of an image and it is worth trying new types until you find some that you are happy with.

Inkjet media

This picture shows a few of the different papers available for inkjet printing. Note the various surface finishes, from glossy to canvas, and the base colours of the papers. These factors have a direct bearing on the way your printed image will look. The surface texture will affect the rendition of detail and maximum black, while the base colour will affect the print tone colour. Both of these will influence the emotional response of the person viewing the print.

Pigment and dye inks

Toneable ink sets

These images show how, using toneable ink sets, the colour of the picture can be changed. I have exaggerated the colours here to make the effect more obvious. Most ink sets can produce very subtle results matching, for example, selenium-toned traditional prints or the heavy toning shown here.

Original monochrome picture

With toneable black and white ink sets it is possible to obtain neutral prints, as shown here, as well as toning effects.

If you intend to make fine prints that are for exhibition or sale, it is important to consider the type of ink you use for your prints. The inks used in inkjet printers are either dye-based or pigment-based, depending upon whether they are formulated from coloured dyes or actual colour pigment. It is generally agreed that pigment-based ink is more stable in terms of colour fidelity and light fastness.

A serious problem for black and white inkjet printing is that inks containing coloured dyes suffer from an effect known as photo-metamerism. Photo-metamerism is seen as a change in image colour, mostly in the shadow tones, when the print is viewed in different lighting conditions. Monochrome prints, either toned or not, made using normal full-colour inks suffer most from this effect.

Light fastness (i.e. the ability of the ink to withstand fading in daylight) is crucial if an inkjet print is to last for many years without showing signs of deterioration and is most important if the print is to be sold in the fine-art market. Pigmented inks have the best fade resistance.

Several manufacturers produce specialized inkjet ink sets for serious digital black and white photographers. These inks may be formulated from pure pigment, pigment with a percentage of dye, or solely dye-based. It is important to know the composition of the ink if you want to avoid metamerism, and reference to manufacturers' websites will provide the necessary information. Most specialized black and white ink sets contain different dilutions of black (greys) in the various cartridges. These grey inks are used for producing the lighter tones without the problem of visible dots that can occur with black-only printing of greyscale images.

Ink sets designed for producing toned black and white prints usually have one or more cartridges containing coloured ink. The colour is added to the other inks when printing to produce the desired image colour. The main specialized ink sets to look at are produced by Lyson, MIS Associates and Cone Studios (sold through www.inkjetmall.com). For pure pigment inks MIS and Cone are recommended.

Split-toning effect

Specialized ink sets make split-toning very easy. In this example, I have added warm colour to the mid to high tones and cold colour to the shadows. All the results shown here are possible with one toneable ink set.

Index

Acknowledgments

As with all my previous books (and everyone else's), I am only one link in a chain of skilled individuals whose talents are brought to bear to turn a book idea into a book reality. Therefore, it is always a pleasure to write this little thank you to all those people working hard at each stage of the project. Thanks.

It is also necessary to say thank you to the people who supplied assistance while I worked on the book. First, to my partner Barbara for all the encouragement. To Bill Dusterwald from www.silveroxide.com for the specialist film simulation filters (you really must try them) and to the manufacturers for supplying product shots for the equipment pages.

Last but not least, I would like to thank you the reader for parting with your hard-earned cash and buying this book. I hope you found it useful. If you have any questions you can email me at les.meehan@zone2tone.co.uk